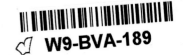

HOW TO
CREATE TEXTURE
IN YOUR PAINTINGS

THE ARTIST'S GUIDE TO USING TEXTURE EFFECTIVELY

HOW TO
CREATE TEXTURE
IN YOUR PAINTINGS

THE ARTIST'S GUIDE TO USING TEXTURE EFFECTIVELY

TONY PAUL

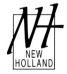

NEW HOLLAND

Published in 2005 by
New Holland Publishers (UK) Ltd
London • Cape Town • Sydney • Auckland

Garfield House
86–88 Edgware Road
London W2 2EA
United Kingdom
www.newhollandpublishers.com

80 McKenzie Street
Cape Town 8001
South Africa

14 Aquatic Drive
Frenchs Forest, NSW 2086
Australia

218 Lake Road
Northcote, Auckland
New Zealand

ISBN 1 84537 048 1

Senior Editor: Corinne Masciocchi
Designer: Ian Sandom
Production: Hazel Kirkman
Editorial Direction: Rosemary Wilkinson

3 5 7 9 10 8 6 4 2

Reproduction by Modern Age Repro House Ltd, Hong Kong
Printed and bound by Times Offset (M) Sdn. Bhd., Malaysia

CONTENTS

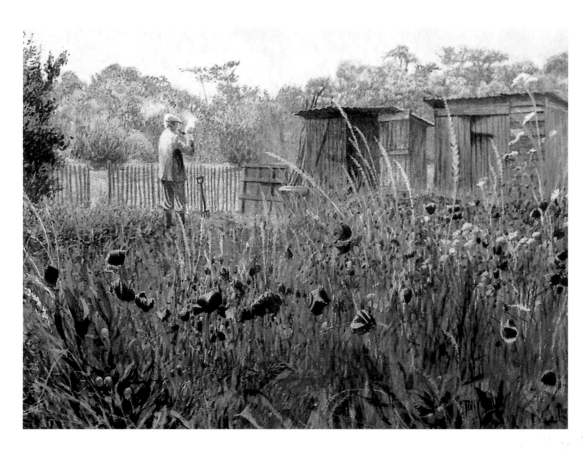

FOREWORD

I first encountered the work of Tony Paul in November 1983, when I was Features Editor at Bournemouth's local commercial radio station, 2CR. That year, the station collaborated with the Western Orchestral Society – the then governing body of the Bournemouth Symphony Orchestra – in a competition for artists to create a programme cover for a gala concert by the Orchestra. In the end the contest proved to be no contest: there was only one choice – Tony Paul. Such was the success of the cover illustration, that Tony was commissioned to create a painting for the programme cover for the following year's gala (see opposite). I suspect these programmes are collectors' items today.

Some ten years later he and I collaborated on a collection of my poems entitled 'This True Making'; I still cherish Tony's evocative illustrations which adorn the book, their sense of mood, their instinctive relationship with the written text, their understated but haunting sense of atmosphere, their texture.

Texture is something Tony Paul understands as much as any painter I know; it manifests itself continually in his own work. He has long been interested in its role within art, the sense of character it gives work, the voice, the living dimension.

He is not only a fine artist; he is a generous and kindly teacher; he believes in guiding his students along their own path, rather than forcing a direction on them. He also believes that this journey should be fun, that there should be humour and above all enjoyment along the way. In a Tony Paul class there are no heavy teaching atmospheres, no pressures: just support, guidance and suggestion, all with the secure assurance that it comes from an artist who is passing on to students a knowledge firmly rooted in practical experience and consummate skill.

Prof. Seán Street
Bournemouth University

RIGHT Music and Champagne, Tony Paul
Oil, 406 x 300 mm (16 x 12 in)

INTRODUCTION

In the 6th century BC, the Greek poet and philosopher Simonedes stated: 'Painting is silent poetry, and poetry is painting with the gift of speech'. If painting is poetry, then surely much of its evocative quality is conveyed by texture.

Texture is relevant to all senses – with touch we feel the contrast between silk and sacking, polished wood and a rose thorn. With taste the tongue can readily detect the difference between toast and cream. One often reads of, and can hear, the different textures that can be found in music, the most abstract yet representational of artistic media.

Even odours could be said to have texture – compare the smell of baking bread to a whiff of ammonia. With our eyes we can feast on the glories of a sunset, or be reluctantly transfixed by a news report showing images of the latest atrocities that one section of mankind is inflicting upon another.

Our senses interrelate and all these textures have one thing in common – they invoke an emotional response. No doubt as you were reading the previous couple of paragraphs you were experiencing just that – a response to texture.

Texture is one of the most important tools for the practising artist. But, in a way, it should be considered an adjective – meaningless unless its description is relevant to the painting. Flashy and gratuitous use of texture will make a work appear coarse and unskilled; lack of texture will make a work look flat and lifeless.

There are two basic avenues that the artist can use to create texture. One is to make a physical, three-dimensional surface by the way the paint is applied, perhaps with heavy impasto or by adding texturing agents such as sand, plaster or proprietary texture gels. Another is by creating an illusion of the textures within the subject in thin paint by the skilled use of a brush, sponge or other means. Sometimes the two avenues are combined, the illusion of description enhanced by the physical character of the painted surface.

In this book you will find numerous ways of creating or representing texture, each illustrated with carefully chosen works showing the techniques in use. As well as my own work, I am delighted to show the work of some remarkable painters who use texture sensitively and creatively. If you are interested in texture, then a feast awaits you.

ABOVE Narramore Farm; Tony Paul
Acrylic, 250 x 355 mm (10 x 14 in)

PART ONE
THE PAINT AND PAINTING TECHNIQUES

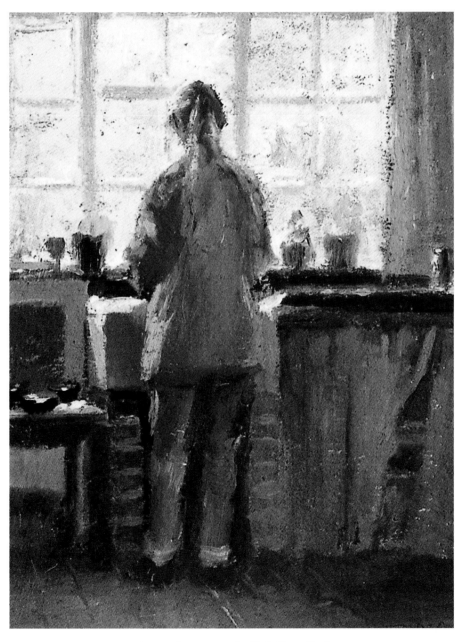

ABOVE Jeanette at the Sink; Tony Paul
Oil, 200 x 150 mm (8 x 5½ in)

OIL PAINT
(and acrylic used as oils)

Canvas

A traditional support for oil painting, canvas is a superb texture to work on. Without doubt the best canvas is linen. This finely woven cloth has random slub threads that run in both warp and weft giving the weave a slightly irregular character with sufficient texture to pull the paint from the brush.

Against linen, cotton and synthetic canvases have a very regular grain that can be fairly pronounced and difficult to cover easily. The painted surface can appear somewhat mechanical and bland. All these cloths will be primed, either with a 'universal primer' – this is suitable for use with oils or acrylic – or (usually for top quality linen) with oil primer, which is suitable only for oil paint.

Canvas board

The cloth mounted on a canvas board is usually a thin cotton or muslin. These boards generally work well, but avoid any that appear to have a horizontal or vertical reeded look. Unless heavy impasto is used these will tend to look a little artificial.

Cheaper boards are sometimes surfaced with a paper that is embossed to imitate canvas and the famous 'Daler Boards' are printed with a textured surface that has a canvas effect. Look for a surface texture that appeals to you but be aware that smoother surfaces can be a little slippery when using oils.

Home-prepared boards

Oil paint needs to be applied to a primed surface to prevent the oil from being drawn out of the paint into the panel. Lead, alkyd and acrylic gesso primers are ideal. MDF (medium density fibreboard) or hardboard offcuts are cheap and provide an excellent base for the primer. The primer should be applied randomly with a bristle brush that will leave brush marks that help pull the oil paint from the brush when painting. Don't prime as if you were painting the panel of a door. My favourite primer is acrylic gesso to which some pigment – red ochre, raw sienna or raw umber – has been added. Some painters add texture paste to the gesso for a more pronounced surface

WATERCOLOUR
(and acrylic used as watercolour)

Watercolour paper

Acid-free paper, made either from treated wood pulp or cotton, is the standard support for watercolour painting. The paper is sized in the pulp and many of the more expensive papers are also surface-sized with gelatine to make the surface more resilient, making lifting off easier and providing a better surface for multiple washes. Watercolour paper is made in a variety of thicknesses that are indicated by their weight either in imperial pounds per ream (lbs), or in metric grams per square metre (gsm). Generally speaking, the heavier papers are preferred as they will accept a degree of wetting without cockling too much. Three hundred gsm (140 lb) is the most popular weight. For very wet-in-wet techniques, heavier papers are sometimes used to reduce cockling or buckling. Some artists use lighter weights such as 190 gsm (90 lb), but these will invariably cockle even with modest applications of washes, so the paper is generally stretched prior to use.

Watercolour papers are given a variety of surface textures during manufacture that are a result of, or mimic the handmaking process, where textured woollen felts are sandwiched between the sheets and pressed. These textures can vary from cloth-like woven finishes to randomly uneven surfaces. Some textures are one-sided (the other side being flat), while others have a similar texture on both sides. Surface textures are broadly broken into three types:

Rough: (top) the surface of the paper is strongly textured with a deep grain created by coarse felts during the papermaking process. The roughness of the grain makes achieving broken dry brush effects easy and creates interesting grainy washes, but detail is often difficult to achieve on the rough and sometimes broken surface.

'Not': (middle) the term is short for 'not hot pressed', sometimes known as CP or cold pressed. The surface is made using a finer felt. This results in a surface that has a pleasing texture that will still give reasonable wash and dry brush effects, yet be sympathetic to more detailed work.

Hot pressed: (bottom) 'Hot pressed' or HP paper is made in a similar way to Not paper, but towards the end of the process it is fed through heated rollers to flatten its texture. This creates a fairly smooth paper that is ideal where flat, featureless washes and fine detail are the order of the day.

GOUACHE

Paper
Gouache is an opaque watercolour paint that works well on watercolour paper, but if applied reasonably thickly on a flexible support such as canvas or paper it can crack and fall off. With thicker paint it would be better to use boards that have been surfaced with watercolour paper. The texture of the support is a matter of individual taste, depending on the degree of detail required.

Coloured supports
Because gouache is densely opaque, it can be used on coloured surfaces that will act as a mid tone. Tinted watercolour paper is ideal and pastel paper, which is usually thinner than watercolour paper, can be used but the paper will cockle if the technique is too wet. Some painters use mountboards – normally used to frame watercolours – some of which have interesting 'laid' or waffle textures. Again care has to be taken not to make the board too wet or the surface paper, which is usually quite thin, will delaminate, or split into separate layers, from the backing board and blister.

EGG TEMPERA

Paper
Like gouache, egg tempera is a fairly brittle medium that is best used thinly and applied to a rigid surface. Home made egg tempera can be used on standard thick watercolour paper or paper-surfaced board without further treatment, but the manufactured variety contains linseed oil which will leech into the paper and in time rot it. So an absorbent primer such as true gesso (not acrylic gesso) or gelatine should first be applied to seal the paper. Traditional tempera techniques require a smooth textured surface so HP paper is ideal for this medium.

Gesso panels
Gesso panels are the traditional surface for egg tempera paintings. These were originally made from wooden panels primed with a chalky, semi-absorbent gesso primer based on a blend of rabbit skin glue, gilder's whiting (or slaked gypsum), and white pigment. Nowadays, the wooden panel is replaced by one of MDF, hardboard or plywood, but the gesso is still made to the traditional recipe. A good gesso panel will be sanded down to be as smooth as possible, often polished to a dull sheen.

PASTEL

Paper

The 'job description' of a pastel paper is that it should hold pastel well. Smooth paper would be totally unsuitable so manufacturers make their pastel papers with surface textures that will hold a lot of pigment. Some papers have regular mechanical textures that are difficult to fill. These can look very insistent and unnatural, particularly in smaller works. Many pastellists tend to use the reverse side of these papers as they are generally smoother and easier to work with.

Textured boards

Within the last twenty years, lightweight boards with an applied coloured, granular surface texture have become popular largely because they hold a prodigious amount of pigment. One type features a surface made from powdered cork, while others are made with gritty fillers such as pumice or marble dust that effectively grate the pigment from the stick. These boards give strong effects and create less waste than with paper. Water must not be applied to pastel paintings made on many cork-surfaced boards as it will damage the surface. Some manufacturers say that fixing is unnecessary.

Velour

A coloured velour flock applied to a card base provides another good surface for pastel. Again, the surface texture holds the pastel pigment well and handles easily, giving a softer, more diffused effect than the granular types. The flock is coloured to provide a range of suitable mid toned tints but it would be wise not to rely on the fade resistance of these colours. Despite the soft feel of its surface, it is extremely tough, shrugging off harsh treatment, mild wetting and aggressive rubbing out (pointless as rubbing out only softens the surface and doesn't erase).

Sandpaper

The ultimate pastel-holding surface must be fine sandpaper. It is not a surface for the timid as it literally eats pastels, holding the pigment well (unless the sandpaper has an anti-clog ingredient). It is unlikely to be acid free and may darken and become brittle. If it is pre-coloured, the tint used will be likely to fade so don't rely on it to provide colour for the painting. Despite its popularity in some circles, it is not designed for artistic use and some types have been known to deteriorate badly in time.

IMPASTO

We have seen what kinds of texture can be found in our painting surfaces. These will have an effect on how the paint handles and looks when applied. But some paints are capable of textural effects independent of the painting support. Impasto is a technique of painting by layering colour on thickly. Its effects are most often carried out with oil or acrylic paint, both of which, straight from the tube, are thick and buttery in consistency.

The use of impasto in oil painting goes right back to its introduction in the Middle Ages. Some pigments are naturally more dense than others, flake white particularly so, first because it is a heavy pigment and second because it had to be applied in a dense layer to achieve the necessary opacity.

Early on artists added modifying oils and resins to their oil paint so that no brush marks would be evident, giving a flat, featureless surface similar to that of the egg tempera paintings that preceded oils. But as the three-dimensional possibilities of oil paint were realized, artists sought to use its effects creatively by employing coarse bristle brushes that emphasized the textural qualities of the brush marks.

Rembrandt and others of his time found that oil paint's textural qualities were very effective, particularly when describing lace, jewellery and the like. The underlayer would almost be relief modelled using thick, quick-drying colour. This was often drawn into with the wrong end of the brush to give extra definition. When dry, the impasted paint could be washed over with a thinner coloured glaze and the colour wiped off the high points of the impasto. This created three-dimensional effects that the artist could not easily achieve in any other way.

Both palette knives, for mixing paint, and painting knives, for scraping down overworked areas, could also be used for applying paint. Turner used knives extensively in the underpaintings of his later pictures, delighting in the textural effects created when overlaid with thin transparent glazes.

Oil painting became as much a celebration of the quality of the paint texture as the subject, with artists like Monet, who set his colours out on blotting paper to make them stiffer and more suited to achieving the crumbly heavily impasted textures of his later works.

In his oil painting 'Cows, Evening Light', Gregory Davies demonstrates the effectiveness of impasto in creating the effects of shimmering light. Multicoloured touches of paint recreate the textures of the grass and the foliage of the trees. The detail shows how the paint has been built up, colour over colour, layer over layer. Not only is it an evocative subject, well painted, but also a textbook example of how impasto can enhance a painting.

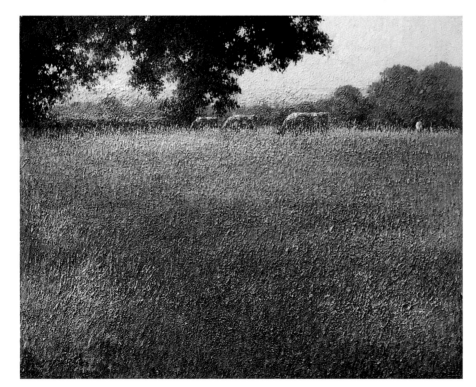

LEFT Cows, Evening Light;
Gregory Davies
Oil; 762 x 914 mm (30 x 36 in)

BELOW Detail of impasto

ADDING SUBSTANCE TO PAINT

Impasto medium
Impasto mediums are used to bulk out oil or acrylic paint, thereby economizing on expensive colours. In oil painting, two problems are associated with impasto that can be mitigated by the use of an impasto medium. The first is the drying time. Colours such as the blacks or alizarin crimson are slow driers, taking many months to dry through. Some oil impasto mediums include an additive that speeds up the drying of thick paint. The second problem is that colours that are high in oil and use pigments with a small particle size – such as the blacks and alizarin crimson – can wrinkle as they dry, particularly if painted in a thick layer. Bulking out the colour with impasto medium will reduce or prevent this unsightly characteristic.

Modelling paste
Because acrylic paint is fast drying it is possible to create heavier textures than would be possible with oil paint, which would be likely to sag badly before it dried. Again, for the sake of paint economy, modelling paste is available to add to acrylic paint. This is a stiffer substance that can either be mixed with the colour or laid on straight from the tub, to be coloured when dry. Adding it to the paint will render the colour more transparent and paler in tone. Modelling paste, particularly if heavily applied, is better suited to a rigid support than stretched canvas.

Sand texture gel

Pumice texture gel

Coarse texture gel

Texture gels
Impasto and modelling pastes will give varying textures depending on what they were applied with as they have no inherent texture. Texture gels contain materials that will give particular granular surface textures. These range from fine, medium and coarse gels, pumice, sand and flint gels and even one that contains small clear glass beads. These are of particular use to abstract painters who, perhaps more than representational painters, rely on the actual surface character of the work to carry the image. These gels can be used singly or in combination with acrylic paint or other pastes and mediums to create a variety of effects. The opportunities for experiment are endless.

On the left is a natural sand texture gel. Paint can be added to it or it can be applied straight from the jar and painted when dry. Alternatively, it can be left unpainted if desired. It can be applied with a brush or knife. In the centre is a pumice texture gel which can be applied straight from the jar for natural stone effects or can be mixed or overpainted with acrylic colours.

On the right is a coarse texture gel which would be more suited to larger paintings. When using these gels, care should be taken to ensure they are in character with the rest of the painting. Effects for effects sake are unlikely to impress the viewer and a heavy texture applied within an otherwise flatly painted picture is likely to look crude and incongruous. Bear in mind that in art it is usually best to understate your points.

BULKING OUT AND TEXTURING OIL AND ACRYLIC PAINT

We have seen what kinds of mediums, pastes and gels can be added to paint, but other substances can be mixed into paint, too. Acrylic paint is a very efficient glue and will accept all kinds of additives, from metal filings to thin string, scraps of cloth, flower petals or tissue. The possibilities are almost limitless. Any non-greasy, lightweight substances will be held well. Should you want to capitalize on the colour of additives, you can mix them with clear acrylic gloss or matt medium. If necessary this can then be painted over.

Acrylic mediums are such efficient adhesives that they can be used as a permanent glue for collage work (some glues will discolour or degrade in time). Oil paint is a different substance entirely and any additions to it should be carefully considered before work begins. Unlike acrylic, oil paint is a poor adhesive and an extremely slow drier. It doesn't have the elasticity of acrylic and it becomes less and less flexible as it ages. Personally, I have never found the need to use additives with oil paint but I know of those that have added plaster, sand and sawdust. Of the three, I feel that sawdust is less risky as it is the least heavy.

Oil paint is unhappy if applied very thickly. It has the habit of sagging and cracking as it dries. Any additions would be likely to add bulk and weight to the paint making sagging more likely, and increasing the thickness of the bulked out paint layer will only retard the drying further. With oil paint the secret is to add only the minimum bulking agent necessary to achieve the required texture – no more than 20 per cent in any event – and to keep the paint layer thin. If a deeper application is needed, the thicker application should be built up by applying several superimposed layers allowing each to dry before applying the next.

Sand

Washed sand should be used because any chemicals in the sand may retard the drying process. If you plan to use a thickly applied layer (or layers), use a rigid painting support rather than stretched canvas as the additional weight of the sand will cause the canvas to sag and distort. In the case of oil paint, the painting should be allowed to dry in a horizontal position so that the weight of the paint is supported until the paint has dried.

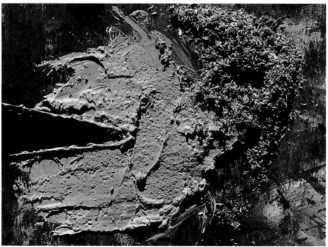

Sawdust

Much of what has been said about sand will equally apply to sawdust. The lesser weight is a great advantage and the greater size of the powdered wood particles will give a coarser effect than sand. Don't use sawdust from MDF as certain types contain carcinogens which, if breathed in, are hazardous to health.

WATER-BASED TECHNIQUES
Watercolour (and acrylic used in watercolour)

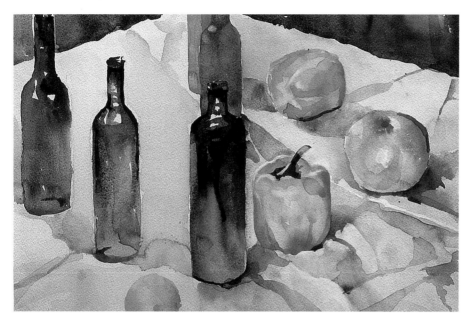

ABOVE Still Life with Bottles; Dennis Hill
Watercolour, 290 x 420 mm (11½ x 16½ in)

Washes

A wash is a layer of paint that is flooded on to the paper with a well-loaded brush. Much of the character and texture of the wash is determined by the surface of the paper used and whether or not granulating colours are used. Washes can be overlaid or blended wet-in-wet. In Dennis Hill's painting 'Still Life with Bottles' we can see how the fluid washes have been blended both wet over dry and wet-in-wet to create a mix of textures. The white of the paper reflected through the transparent watercolour makes the colours glow.

Watercolour – miniature technique

Although washes can be used in miniature painting, and are often used in the underlayers, the traditional technique is to build up the colour in thin, stippled layers that let the light shine through from the base. Care has to be taken to maintain transparency to avoid a hard and crude appearance. Short-haired round 'spotter' or 'detail' brushes are often used because they hold less paint and will deliver tiny amounts of colour in a very controlled way.

LEFT Lady in a Hat; Pauline Gyles
Watercolour, 100 x 76 mm (4 x 3 in)

OIL TECHNIQUES
(and acrylic used in oils)

ABOVE Cabbage Field, Dunster, Tony Paul
Oil, 152 x 228 mm (6 x 9 in)

Alla prima

Oil paintings that are completed in 'one wet' (i.e. before the paint dries) are often known as being painted alla prima. These are usually smaller works painted in front of the subject. I painted 'Cabbage Field, Dunster' on a small panel, primed roughly with acrylic gesso mixed with raw umber pigment to give a mid tone. I wanted the texture of the paint to be apparent and so used it straight from the tube with no solvent added. The rough textured surface pulled the pigment from the brush and, with the low impasto of the paint, helped create an interesting surface. In parts the raw umber priming was allowed to show through.

Layered glazes

In the times of Rembrandt very little oil painting other than sketches was done alla prima. The usual technique was to complete an underpainting either in greyish tones or in basic colours, which was then allowed to dry. The underpainting was then overlaid thinly with colours mixed with a painting medium to make them transparent. Layer after layer could be applied, giving a real sense of depth to the work.

Peter Kelly favours this old master technique and in his painting 'Dominican Monastery', a tremendous sense of depth has been achieved in the dark areas and in the beautifully gradated floor – a depth that could never have been achieved by a single layer of paint.

RIGHT Dominican Monastery, Peter Kelly
Oil, 508 x 330 mm (20 x 13 in)

GOUACHE AND EGG TEMPERA TECHNIQUES

Gouache

Gouache is a versatile medium that can be thinned almost to imitate watercolour, or applied densely to obliterate what lies beneath. It is not suited to high impasto, as thick paint will tend to crack and fall away. Its great advantages are that it is quick drying and light colours can easily be painted over dark. In my painting 'Artist's Garden' I blocked in the dark of the background, the light green of the sunlit lawn and darker green of its shadow, before taking up a small brush using detail to create the various textures.

Egg tempera

Unlike the opaque gouache, egg tempera is translucent and has a more delicate touch. The paint cannot be applied thickly, but is generally applied in small thinly hatched or broken strokes. Usually painted on smooth gesso panels, texture has to be described rather than created by a build up of paint. My tempera 'Statue, Stapehill Abbey' demonstrates how the textures in the painting have been worked up over a basic underlayer by using small touches of the brush applied layer over layer. The painting dries quickly to give a flat, matt surface.

ABOVE Artist's Garden; Tony Paul
Gouache, 254 x 203 mm (10 x 8 in)

ABOVE Statue, Stapehill Abbey; Tony Paul
Egg tempera, 254 x 203 mm (10 x 8 in)

PASTEL TECHNIQUES

Pastel is the most immediate and fastest of the painting media. Because it is dry, colour can be laid over colour in rapid succession. Broad sweeps of colour can be achieved by laying the pastel on its side while small touches drawn with the end of the pastel stick will help create detail. Pastel pigment is held in the tooth of the paper so piling it on won't work, as it will fall off unless you apply fixative to consolidate the layers. The sketch, a demonstration at one of my portrait classes, took only a matter of twenty minutes. It was painted on the reverse (smoother) side of a pastel paper. Note how I have drawn with the end of the pastel, allowing the background to show through in places. This acts as a mid tone which, because of its colour, reads as shadow.

Highly finished work

By rubbing in a primary layer of colour, using a finger or a sharpened roll of paper known as a stump, smooth gradations can be made. Layer can be applied over layer and sharp details will give crisp, finishing touches. My pastel 'Still Life with Grapes' was worked in this way. I used a purplish grey textured pastel card as the support, and after drawing the subject I applied broad sweeps of colour for the background and table top. These did not fill the surface grain of the card so I used my fingers to smoothly blend the colour, while for the clementine, brass bowl and grapes, I used the point of a stump to fill the grain and soften edges. Highlights were added with pastels that had been pared to give a sharp edge or point.

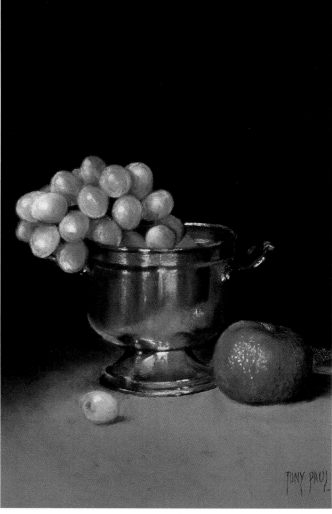

ABOVE *Portrait Study*; Tony Paul
Pastel, 356 x 254 mm (14 x 10 in)

ABOVE *Still Life with Grapes*; Tony Paul
Pastel, 254 x 203 mm (10 x 8 in)

SPECIAL EFFECTS

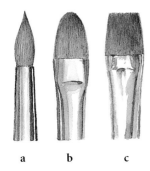

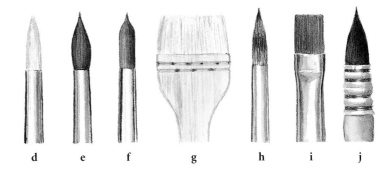

a　　　b　　　c　　　　　　d　　　e　　　f　　　g　　　h　　　i　　　j

Brushes

The primary tool of the artist is the brush. It is a superb tool, capable of delivering colour in a predictable and controlled way to the painting surface. For the beginner, visiting a well-stocked art shop can be more confusing than elucidating. Row upon row of brushes of different shapes, colours and hairs meet the eye. So, which brush does what?

The top left illustration shows the three main types of brush. The round brush (a) can make strokes that vary from a thin line to a broad band of colour, depending how much pressure is put on it. The filbert or 'cat's tongue' brush (b) is designed to give a softer, less angular stroke than the flat brush, its flattened head giving a broad stroke. Turning the brush through 90 degrees will enable the narrow edge to be used for thinner marks. The flat brush (c) has become the standard workhorse of the artist, particularly with oil painters, delivering paint evenly in a broad sweep. Its edge is also capable of making narrow strokes.

The top right illustration shows the kinds of hair from which brushes can be made.

Hog hair brushes (d) are favoured by oil and acrylic painters because of their stiffer spring, even when heavily loaded with thick paint. Made from the bleached back hairs of pigs, they leave prominent brush marks. 'Hogs' are made in all shapes, but because of the coarseness of the bristles, the point in the round brush is not as sharp as with other hairs. Hog brushes are made with long or short handles. Oil painters generally prefer to stand back from their work while painting, so usually select the long handled variety.

The sable brush (e) is made from the tail hairs of the Siberian mink. The hair is springy and can hold a good quantity of paint. The great asset of sable hair is that each hair bellies out in the middle of its length and tapers to a fine point at its end. The hair is expensive and used to make high quality watercolour brushes. Some artists use sables for oil painting or acrylics, but the rough surfaces and harsh solvents used in oil painting will quickly ruin a sable, and acrylic is difficult to clean from natural hair brushes, so reducing the time that they will hold their shape before splaying like the 'ruined brush' overleaf. Because the hair is so expensive, most manufacturers also make a cheaper brush that has a blend of synthetic and sable hair which has some of the performance of sable at a reasonable cost.

Synthetic fibre brushes (f) are cheap to buy and are popular substitutes for more expensive hair types. They are made in various weights of filament, capable of imitating any natural hair. For oil painting, I prefer the stiffer, burgundy coloured synthetic hair brushes to hogs as they wear and hold their shape better, are much cheaper and give a less scratchy mark. Beginners often use the finer, golden coloured hair brushes for water-colour work. They do not quite have the control or paint holding capacity of the sable, but manufacturers are making improvements to the fibres used.

The hake brush (g) originates from China. It is well priced and used for applying broad watercolour washes. The brush is made with white goat hair, which is fairly coarse and capable of holding a lot of paint.

Mongoose hair brushes (h) made for oil painting are stiffer than sable but softer than hog. They point better than hog and the tapering hair gives a finer finish with softer brush marks. However, they are not as hardwearing as either hog or synthetic brushes.

Ox ear or pony brushes (i) are made with a fairly coarse, springy hair that looks like, but doesn't have the characteristics of, sable. It is sometimes blended with sable to make a cheaper brush. In past times, these brushes were often used by sign writers.

Squirrel brushes (j) are used for watercolour. Often bound to the handle with goose quill and brass wire, these fine-haired brushes hold a prodigious amount of colour. They are also capable of making a fine point for adding detail. The hair is limp in comparison to other hairs and when moist has little 'feel'.

SPECIAL EFFECTS BRUSHES

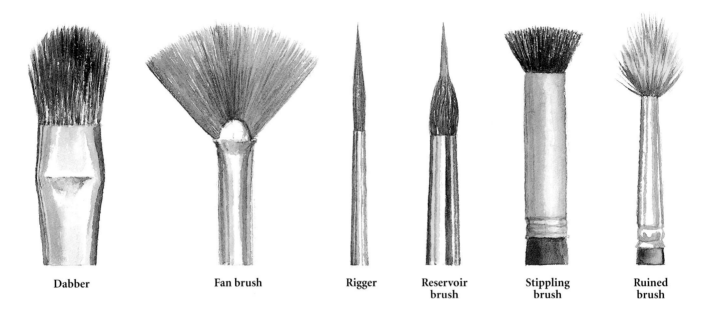

Dabber **Fan brush** **Rigger** **Reservoir brush** **Stippling brush** **Ruined brush**

Dabbers are made from a mix of soft and coarser hair to create textures such as foliage, dry brush effects and stippling. The brush can be used for any medium, even oils or acrylics if thinned.

The fan brush was originally made for blending oil colours and softening out brush marks but nowadays it is often used to create foliage effects, particularly in watercolour.

The rigger brush was originally used to draw ship's rigging in marine paintings, the long hair carrying sufficient paint to complete the line in one stroke. Some artists use it to replace small round brushes in their pursuit of fine detail.

Even riggers sometimes run dry, so the reservoir brush was invented which has an inner part of sable, similar in form to a rigger, surrounded at its base with high capacity squirrel hair.

Stippling brushes can be used to imitate linear or dotted textures such as grasses or sand. These are available in soft or firm haired versions.

The last brush is one of my favourite tempera brushes. Originally, it was a slim, synthetic round brush, but using it for acrylic for a few months caused it to splay at the ferrule, dividing the hair into a dozen or more points. I use this 'ruined brush' for dotted or foliage effects and for fine cross hatching over larger areas.

Figure 1

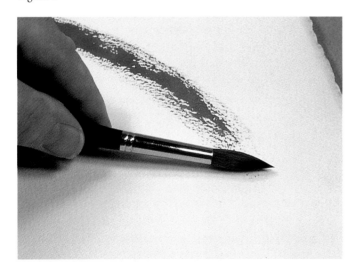

Figure 2

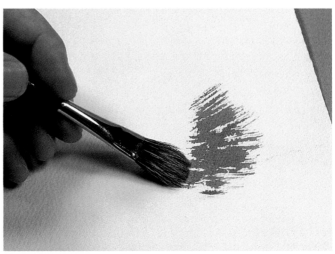

Dry brush effects (Figure 1) can easily be created by dragging a partially loaded brush quickly and lightly across the painting surface. It is best that the paint in the brush is fairly dense, but not too fluid.

Figure 2 shows the dabber in use. See how it gives a broken, almost dry brush mark ideal for foliage effects.

The fan brush (Figure 3) is used for its original purpose of blending colours into one another. It is held vertically and wiped when it becomes clogged with paint.

Splaying the hairs of a round brush (Figure 4) will create several points that will reproduce fine foliage or grass effects.

A synthetic brush ruined by use with acrylic is ideal for creating the small marks and hatched textures that I use for my tempera paintings (Figure 5).

The fan brush again (Figure 6), but this time used to create fronds of foliage. The brush splays into multi-points when wet, giving interesting broken textures.

Figure 3

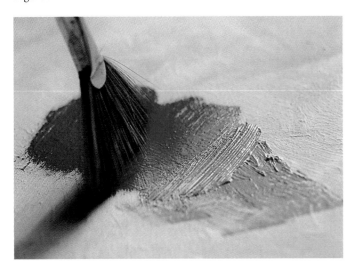

Figure 4

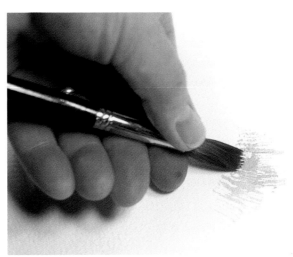

Figure 5

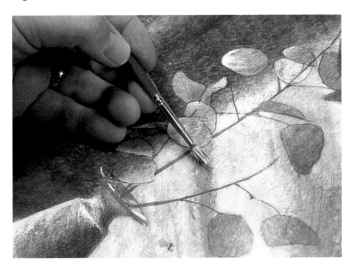

Figure 6

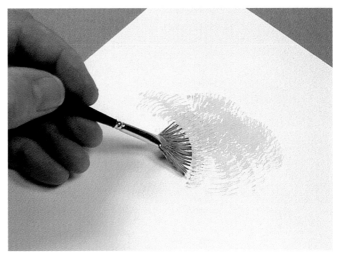

SPONGES

Sponges are ideal to create texture in paintings. It is best to use those that have an open texture such as that to the right. Using one with a fine texture will not work well unless torn so that the torn edge is used to print the texture. Layer upon layer can be overlaid to create shimmering effects, but make sure that each layer is dry before applying the next otherwise you may pull off more than you put on.

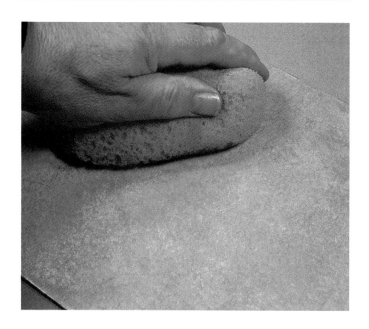

'Cats at Carnac' is an egg tempera painted on a sponged over base. The sky – a multi layer sponging of green, orange, pink, yellow and blue, was applied all over the panel. I then placed paper over the sky area and sponged multi layers of similar but darker colours from the horizon line to the bottom of the painting. The sand, the catamarans and the quays were dabbed in multi layers over the underpainting using a 'ruined brush' (see page 22), then a fine brush was used to refine the details.

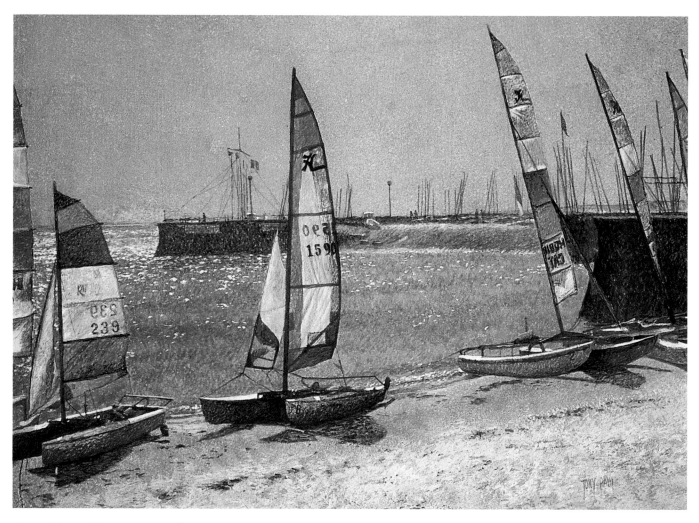

ABOVE *Cats at Carnac*, Tony Paul
Egg tempera, 254 x 356 mm (10 x 14 in)

MASKING AND SPONGING

As you may have noted from my description of the painting of 'Cats at Carnac', I put paper over the sky to obtain a crisp horizon line when sponging over the sea. Using a mask is a very useful technique when sponging. If I want to paint a brick wall I can mask off where the mortar should be and then freely paint the multi-layered brick texture all over the painting. Lifting off the mask will then reveal clean edges that can then be painted to represent the mortar.

Masks can be paper with holes cut as appropriate and laid over the painting surface. But unless it is for a single layer, paper is inclined to become soggy, move and, if made too wet, break up. So for multi layers, use low tack masking film – made for use in airbrushing – masking tape, or tape edged plastic or polythene sheet if the masked area is large. Be sure that the tape is low tack or you may pull the surface from the painting support and end up with textures you hadn't anticipated. I used low tack masking tape to create the masks for 'Garden Spider'.

Painting the mortar was easier over the white of the paper. I painted a black area to create the hole in the mortar and used cerulean blue for light within the shadows. The texture of the mortar and the extra texturing on the bricks were done using my 'ruined brush'. The web was drawn lightly with a fine brush and the spider was painted in making sure that the light on it was consistent with the general effect of light.

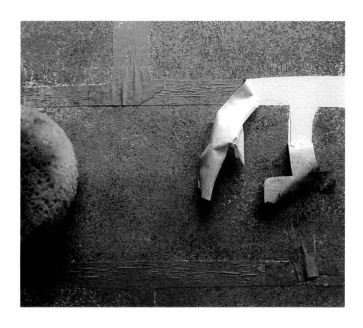

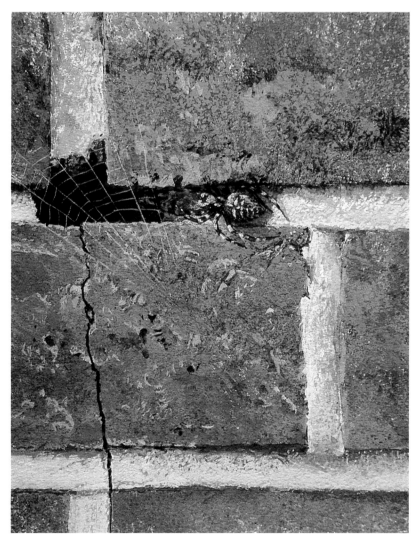

RIGHT Garden Spider, Tony Paul
Gouache, 227 x 210 mm (9 x 8¼ in)

TORN SPONGE FOR FOLIAGE

A good open textured sponge is ideal for creating random foliage. Some people use natural sponges, which are usually small, expensive and sometimes too fine in texture. The ideal sponge will come from the supermarket or the auto spares shop. These are consistent in their randomness and cheap to buy.

In a matter of seconds a good sponge can create textures that would take an eternity using a brush. The paint should be applied thinly to an old plate and the colour should not be too wet or diluted. Prior to this, the sponge should be wetted and excess water squeezed out – if you dip a dry sponge into paint, most of it will be used up in moistening the sponge and little will be transferred to the painting.

When using a sponge for watercolour, a wetter approach can be used to imitate a broken wash. If using the sponge for larger areas of sponging, don't forget to continually turn the sponge to offer a new face to the painting, otherwise there will be a mechanical repetitive pattern that will look odd. You may wish to overlay to create depth to the foliage. This can be done by adding colour wet-in-wet or wet over dry. The choice is yours.

Because oil paint is a glutinous medium, the paint can be mixed on the palette and picked up from there by the sponge. A more fluid paint will give a softer texture, while thick paint straight from the tube could result in so much paint being applied that the painting appears to have stalagmites – fine if the rest of the painting is similarly lumpy, but odd if it is painted reasonably flatly.

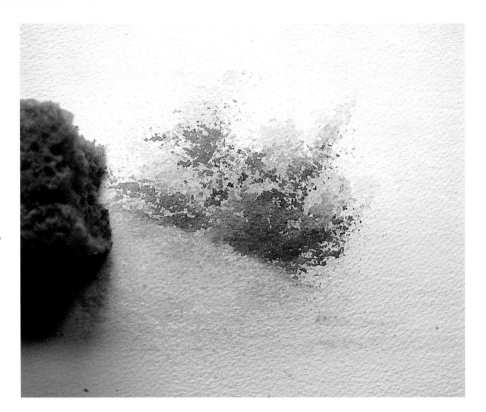

PRINTING

Almost anything that holds paint can be used to print shapes or textures on to a painting. Leaves, painted and pressed into the surface with a rolling pin, cloth, bubble wrap, stripped corrugated cardboard and many more too numerous to mention can all be used.

I thought I would use a printing technique that I learned at primary school: using a potato cut. This is useful where you need a repetitive simple shape but it must be remembered that you are unlikely to get a perfect print each time, so if perfectly crisp reproduction is necessary it would be better to stencil the shape through a mask.

To print a leaf shape, first cut the potato in half, then carefully incise the leaf shape into the cut face of the potato. Then cut around the leaf shape aiming to leave it 0.5 cm (¼ in) proud. The cut was chamfered to slope back from the leaf shape, so that when printing you can see where you are placing the image, then mix various greens on a plate ready for printing.

As you can see in 'A Rose by any Other Name', I used various greens, printed partially over one another working from dark to light, to imply a dense rose bush. The pressure applied to the potato sometimes squidged the egg tempera paint to create an outline. The variety of marks that it made created interesting and lively foliage textures.

LEFT A Rose by any Other Name;
Tony Paul
Egg tempera, 305 x 240 mm (12 x 9½ in)

SPATTERING

Spattering paint on to a painting can create wonderfully granular effects such as sand, stone, gravel, tarmac, etc. Applied layer over layer spattering can achieve a good sense of depth. Spattering can be achieved by any method that throws tiny droplets of liquid paint on to a painting. For coarse effects, use a mouth spray used to apply pastel fixative, or strike a loaded brush against your hand, allowing centrifugal force to spatter droplets on to the painting. A mask can be placed over the painting to protect areas where this effect isn't needed.

For the egg tempera 'Sea Jewels', I used an old toothbrush to create a fine spatter, which I applied layer over layer. Using different thicknesses of paint or using a lightly or heavily loaded brush will create different grades of spatter, and it is easier to aim the spatter from a toothbrush than from most applicators. I used a palette knife to brush the bristles back. When released their spring threw the fine droplets on to the painting. The shells were painted with a small brush. Sgraffito (see opposite) was used to scratch out the lines on the mussel shell.

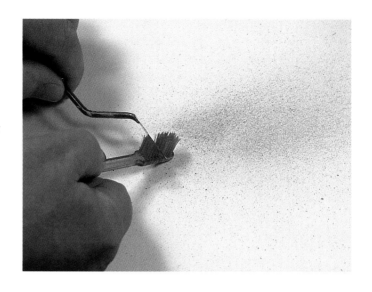

BELOW Sea Jewels; Tony Paul
Egg tempera, 200 x 250 mm (8 x 10 in)

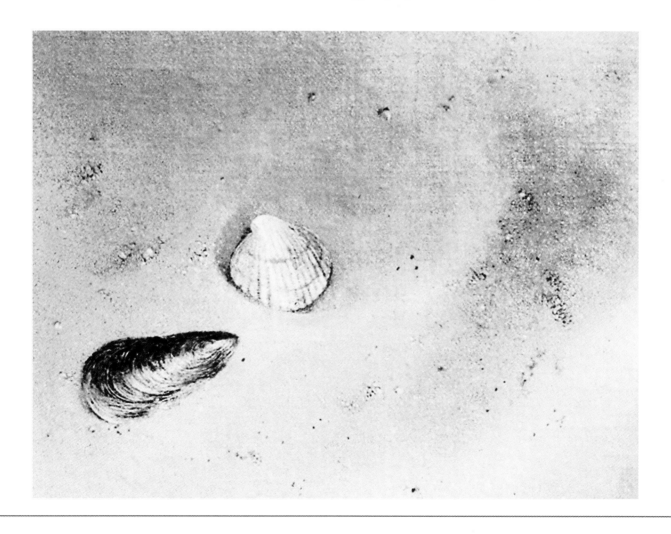

SGRAFFITO

Sgraffito means scratching out. It involves using a pointed instrument to displace the paint in a picture or, in the case of a watercolour, to scratch the surface of the paper with the point of a knife to create highlights, such as sparkle on water.

Rembrandt was well known for scratching through wet oil paint with the wrong end of the brush to create textural effects and Singer Sargent used it to describe the masts and gunwales of the moored boats in his oil 'Venise par Temps Gris' painted in 1880.

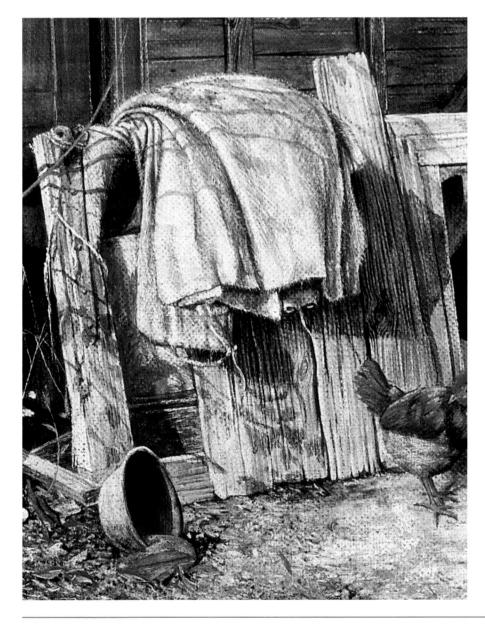

In the detail from my egg tempera 'The Barn Out Back of Noisy Dave's', sgraffito has been used extensively to create the fluffy edge to the sacking and also the grain of the planks of wood. I used a scalpel to scratch through the thin paint to reveal the gesso underneath. In egg tempera, several layers of sgraffito, each washed over in transparent colour, are an effective way to build up a texture that represents thick grass.

LEFT The Barn Out Back of Noisy Dave's (detail); Tony Paul
Egg tempera, 400 x 305 mm (15½ x 12 in)

CARD EFFECTS

When your credit card expires don't throw it away – it can be used to create textures in paintings. When well used the result will have something of the character of an etching, being quite graphic in quality. Watercolour washes are applied and the plastic card, or a piece of it used to 'squeegee' the paint will create shapes. A pale remnant of the colour will remain in the texture of the paper and will be concentrated at the end of the stroke, where it can be mopped up. Drawing into the wet paper with the edge or corner of the card will create linear dents in the surface where the colour will be stronger. When dry, conventional painting techniques can be used to develop the subject.

In her watercolour painting 'Venetian Scene', Frances Shearing uses the technique with three different washes. The first wash is the sky, which was drawn down using only slight pressure. In the second wash in which the buildings were created, the card is drawn down applying a firm pressure and only a slight residue is left in the tooth of the paper. See how the residue has collected at the bottom of the stroke. The third layer is drawn down with a fairly light touch and the corner of the card is used to suggest the movement of the water. Once dry the painting was developed using traditional techniques.

ABOVE Venetian Scene; Frances Shearing
Watercolour, 200 x 160 mm (7½ x 6¼ in)

SCUMBLING

Scumbling is normally used in opaque media but can be done with opaque pigments in watercolour. Usually, a lighter or darker underlayer of paint than will eventually be required is applied and allowed to dry. A brush, lightly loaded with dense paint, lighter or darker in tone and often of a different colour is then scrubbed roughly over the underlayer so that it veils and amends the colour underneath, rather than obliterating it. In this way, thin scumbles can be built up one over the other, each slightly modifying the previous layer.

The broken and veiling qualities of scumbles create great richness and character to a painting, some marks break on the surface of the support to create interesting textures such as dry brush effects. In Peter Kelly's oil painting 'Storm Clouds Over Woolwich' we can see the multiple scumbles that have been used to brilliant effect, not only in the sky, but also in the water. These have wonderful modulations and create effects that could not be obtained in a single layer of painting.

ABOVE Storm Clouds Over Woolwich; Peter Kelly
Oil, 305 x 457 mm (12 x 18 in)

SALT

The hygroscopic qualities of salt can be used to effect by the watercolour painter. If sea salt is sprinkled into a wet wash it begins to soak up the colour and after a few minutes it dries leaving an effect that can look like lichen or concrete.

In her painting 'Pomegranate', Frances Shearing has used this technique extensively for the background, after masking off the pomegranate and the curled leaves. The effect is almost like hundreds of small florets, but in the context of this painting is meant to represent hardened earth or concrete. She has used some accidental edges to create fissures in the ground, emphasizing its granular character. The pomegranate and leaves were painted later using conventional painting techniques.

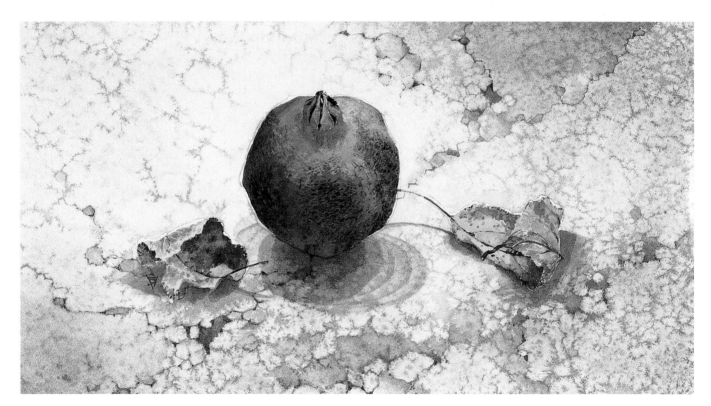

ABOVE Pomegranate; Frances Shearing
Watercolour, 152 x 305 mm (6 x 12 in)

PVA AND PLASTER

PVA glue has a resist effect that will greatly soften or repel overlaid watercolour washes. It can be used on its own or given a higher impasto by adding plaster of Paris. There is no one way of working it, but often a basic underpainting is completed and the PVA, or a mix of PVA and plaster worked over. The PVA will dry transparent but when the plaster is added it will dry white.

The effect is almost sculptural and capable of varied textures depending on how it is applied: sponging, palette knife and brushing are three methods. PVA can also be sanded or carved to vary the surface quality. Paint is then applied over this surface texture. The liquid and transparent watercolour paint will run into the crevices and dry darker than on the surfaces containing more PVA. Where there is more plaster than PVA, the colour will be stronger as it will soak in. In the painting 'Landscape', the heavy texture of the PVA and plaster

can be seen. This has been sanded in parts and multi coloured washes applied. The colour has an almost sugary quality, and the surface has a wonderfully crumbly texture.

ABOVE *Landscape*; Frances Shearing
Watercolour, 203 x 305 mm (8 x 12 in)

PLASTIC WRAP (Clingfilm)

It is amazing how the painter will adapt seemingly foreign materials and use them in his or her picture making. At first sight it may surprise you that some quite dramatic textural effects can be created using this thin plastic. There are two ways in which to use plastic wrap. The thin film itself can be painted, then laid paint-side down on to paper and the film scrunched and pulled to create patterns or textures or, more commonly, a wash is applied and the dry film laid over the top and manipulated into shapes and creases.

You can then either lift off the plastic wrap before the paint is dry – this will allow the edges to soften and blend a little – or leave the film on until the paint is totally dry – this will give sharper effects that can look like etched aquatint. Beware of trying to dry the paint through the film with a hair dryer, unless you are careful it will blow the film right off the paper. In her painting 'On the Sea's Fringe', Frances Shearing has laid a wet-on-wet multi-coloured wash and scrunched up the film to suggest foamed water over coloured rocks at the sea's edge.

BELOW On the Sea's Fringe; Frances Shearing
Watercolour, 140 x 215 mm (5½ x 8½ in)

LIFTING OFF

Lifting off is a technique that can easily be used in all media except acrylic, which normally dries too quickly and is then insoluble. Lifting off involves removing paint to reveal the surface underneath. This may be an underlayer of dry paint or the white of the paper or canvas. It can be done to relieve a bland wash, to soften an area of tone or to add detail.

Lifting off is most often used in watercolour. On the right is a section of sky painted as a flat wash using a non-staining blue (manganese blue hue). Instead of leaving the clouds as white paper, thereby creating difficulties in achieving a flat wash, the colour was quickly applied and while still wet twisted kitchen roll was used to lift out the cirrus clouds. The twisted paper was rotated to give a different cloud shape each time.

In the gouache 'Low Tide, West Bay', I painted the dark harbour wall in a flat, non-staining mix of ultramarine and burnt umber. When dry, I drew the lighter detail of the vertical rubbing bars and the piled concrete breakwaters with a wet brush, leaving it for thirty seconds or so for the paint to soften before dabbing it out with kitchen roll. This revealed the grey paper beneath.

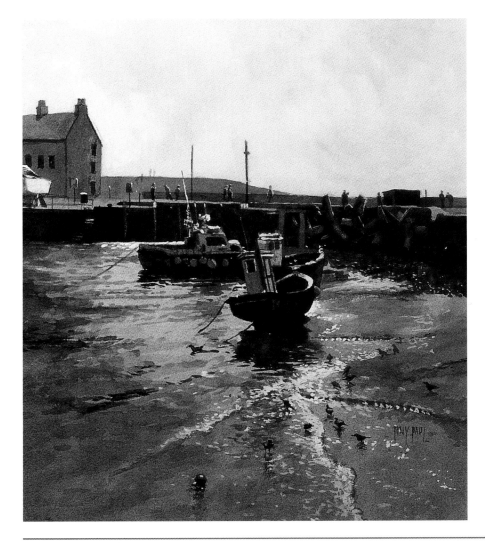

LEFT Low Tide, West Bay, Tony Paul
Watercolour, 279 x 254 mm (11 x 10 in)

PAINTING KNIVES

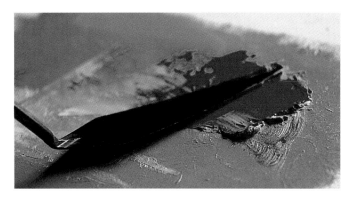

Painting knives can create some wonderful textures in paintings. The history of western art is full of works which, in some areas, have been extensively worked with painting knives. Some painters use them not only as a secondary tool for mixing paint, scraping back or creating minor 'dry brush' effects, but throughout the picture as the sole tool for applying paint.

Changing the pressure on the blade, or varying the quantity of paint creates different marks. The edge gives sharp lines and when used flatly, broad sweeps of colour can be applied.

In his painting 'Connemara, Early Morning Light', Alan Cotton used painting knives throughout, finding them surprisingly sensitive and responsive. There is a strong feeling of structure in the painting, particularly in the land, which undulates towards us, the low light sharply modelling it.

BELOW Connemara, Early Morning Light; Alan Cotton Oil, 915 x 1016 mm (36 x 40 in)

FROTTAGE

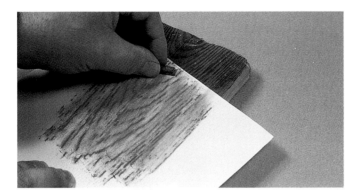

Probably the best known use of frottage is in making brass rubbings. Frottage involves placing thin paper over a textured surface and then rubbing over it with pencils or crayons so that the high points of the object's surface are replicated leaving the hollows as plain paper. Frottage isn't good at subtle or fine texture but will render weathered wood, stone, brick and the like very well.

I used coloured pencils for my illustration 'Red Admiral'. The reverse side of an old floorboard was used as the surface over which I placed a sheet of lightweight Ingres paper. I drew on the smoother side and was careful to hold the paper still to avoid double images. I sharpened the pencils into a long point and used them on their sides rather than on their points, transferring the image from the wood.

My first step was to draw the shape of the butterfly so I wouldn't go over it when rubbing over the wood. The first layer of frottage was with a grey-green pencil, the second, using a blue-grey pencil at a slightly different angle so I didn't get an absolute overlay. The third and final overlay, applied more randomly, was a mid brown. With this completed, I worked on the butterfly using a damp brush to melt the colour into the grain of the paper. The final touches were the detail of the nail heads and their rust stains and crack details. Lost light edges were reinforced with white gouache.

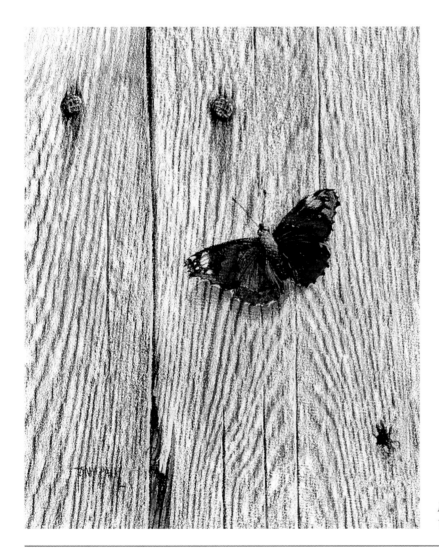

LEFT *Red Admiral*; Tony Paul
Watercolour pencils, 254 x 203 mm (10 x 8 in)

WAX RESIST

Watercolour painters, who work from light to dark, often have difficulties in retaining the white of the paper. Masking fluid can be used, but if applied over a colour it can be difficult to lift off without taking the surface off the paper. Wax will repel water and because it is transparent need not be removed after the painting is completed.

The wax must be applied carefully because once it is on it will remain – there is no second chance. With wax it is possible to create finer textured lights than with masking fluid, particularly on rough watercolour paper such as that used for my painting of 'San Giorgio Maggiore from the Lagoon'.

I began by carefully drawing the church buildings, then washed them in three layers to create the tones. I drew with

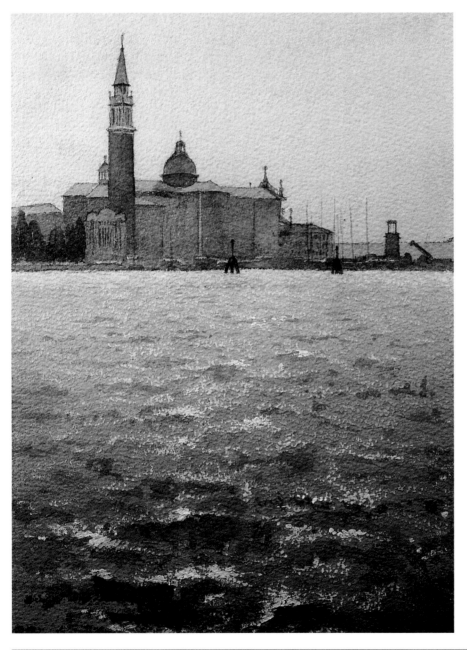

a sharpened piece of candle in the areas that I wanted left as a white shimmer – fairly densely, but finely at the horizon then first finely, but becoming coarser and larger as I worked towards the bottom of the painting. I had to tilt the painting so that I could see from its shine, where the wax was.

When I was satisfied with this layer, I washed in the distant land and let it dry. I then washed in the sky, making it paler towards the horizon, then washed over the sea, darkening it progressively as I worked down. Immediately I could see the wax repelling the fluid colour. When this was dry I rubbed on some more wax and then washed the sea over with diluted raw sienna. The final wash, which was run over the whole painting, was of permanent rose. A final touch was to add shadow to the waves that had been suggested by the resist and touch in extra highlights with white gouache.

LEFT San Giorgio Maggiore from the Lagoon; Tony Paul
Watercolour, 293 x 204 mm
(11½ x 8 in)

PART TWO
TEXTURES IN LANDSCAPE

ABOVE View over Pollensa; Tony Paul
Oil, 660 x 508 mm (26 x 20 in)

SKIES AND CLOUDS

Cloudless skies

Sometimes students paint cloudless skies as a plain block of blue colour and, in small areas it can appear like that. But the sky will change colour in relation to the sun and will usually both lighten and change colour as it goes to the horizon.

If you look hard at the sky you will see that it isn't a flat colour. It can appear mottled, a mix of similar toned but subtly different colours that blend to give the impression of a single hue. In 'A View from Monte Toro, Menorca' I have painted such a sky. Painted with random brush strokes that blend the colours together, the painting has a feeling of space and heat.

Light cloud

Light cloud can easily be represented in watercolour by lifting out the wet sky colour with scrunched up kitchen roll. This will give a soft, irregular edge, which can be adjusted as you wish. If you are dabbing off a band of cloud don't forget to re-scrunch your tissue to get different shapes. Cirrus and mackerel skies can me made using twisted kitchen roll as described on page 35.

In oil paint, clouds are best applied over the pre-painted sky with a filbert brush lightly loaded with dense white paint. If the clouds appear too white, add a touch of Naples yellow to quietly soften them. For these light, fluffy clouds I try to touch, rather than brush, the paint on to the canvas.

LEFT A View from Monte Toro, Menorca; Tony Paul Oil, 508 x 356 mm (20 x 14 in)

CLOUDED SKIES

Dense cloud that blocks the sun can appear very dark. In my tempera of Maiden Castle we can see how the heavy cloud creates a low light that reinforces the forms and textures of the landscape. In 'Bertie Takes the Lead', the heavy clouds are modelled with violet-grey shading. As the clouds go to the horizon their definition decreases. Note how the brilliance of the sunlight is created by making the shadows deep toned.

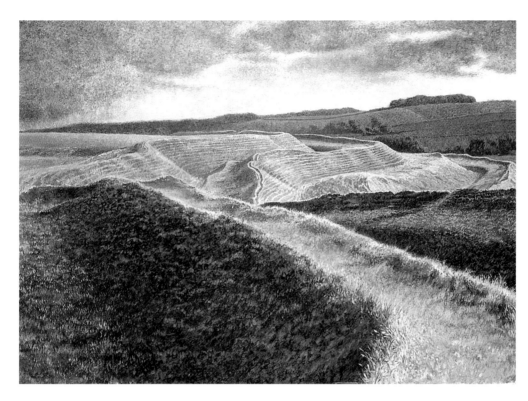

LEFT *Maiden Castle*; Tony Paul
Egg tempera, 430 x 600 mm
(17 x 24 in)

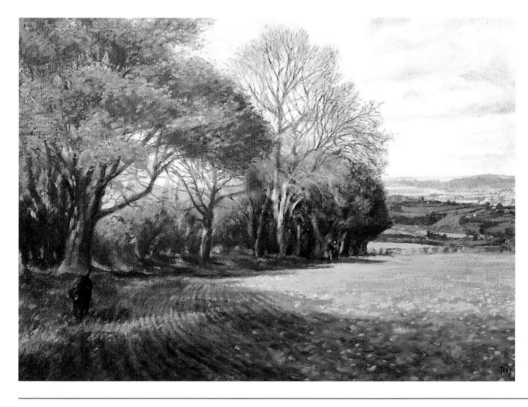

LEFT *Bertie Takes the Lead*;
Tony Paul
Acrylic, 508 x 762 mm
(20 x 30 in)

FIELDS AND GRASSES

The way that you treat fields and grasses depends on several factors: the medium used; the direction of light and the length and type of grass. Representing them in detail is much easier in an opaque medium as you can build up the textures working layer over layer.

Grasses become darker as they get closer to the ground because they are shaded by surrounding grasses so it is the upper parts that catch the light. If you are using an opaque medium you can scrub in the darks and pull the seed heads, wildflowers, etc. out, using lighter colours as I have done in the tempera 'White Farm, Talbot Village'. With watercolour, however, unless you add white paint (and possibly lose the character of watercolour), you have to paint from light to dark. For detail work in watercolour it will be time consuming and probably tedious painting in the darks as negative shapes. A loose technique that 'suggests' rather than describes the textures in detail is probably the best approach.

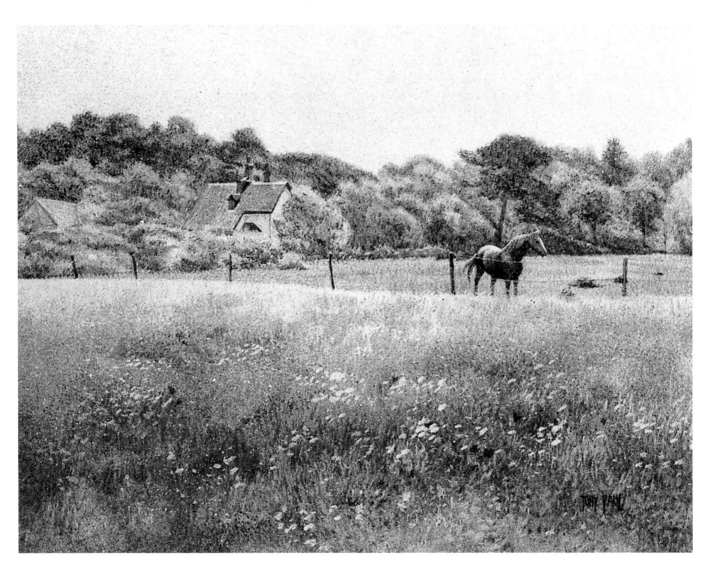

ABOVE *White Farm, Talbot Village;* Tony Paul
Egg tempera, 254 x 305 mm (10 x 12 in)

FIELD TEXTURES – DIFFERENT APPROACHES

The loose approach was used in the watercolour sketch 'A Corner of the Farmyard, Narramore Farm'. The texture of the grass is implied by the random opposition of dark and light patches that have been given a vertical emphasis to imply clumps of grass. The tones and colours have been varied to imply humps and hollows, trodden areas and plants within the grass.

My tempera 'The Wild Patch' is painted using layer upon layer of semi-opaque paint. There is a lot of suggestion of detail with fairly resolved poppies, seed heads and flowers. To give a feeling of space, the colours and textures of the gardener, the huts and background trees have been subdued to off-greys, the colours becoming brighter as they come forward.

ABOVE A Corner of the Farmyard, Narramore Farm; Tony Paul
Egg tempera, 254 x 355 mm (10 x 14 in)

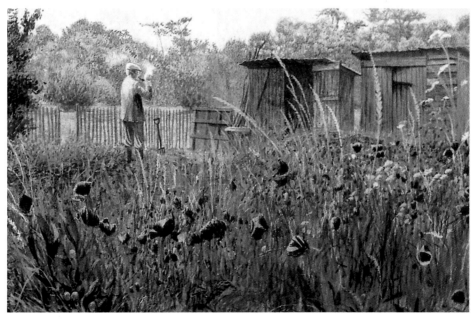

ABOVE The Wild Patch; Tony Paul
Egg tempera, 254 x 355 mm (10 x 14 in)

TREES AND PATHS

ABOVE The Woods, Talbot Village; Tony Paul
Oil, 406 x 305 mm (16 x 12 in)

The most important aspect of painting trees is to achieve a feeling of depth otherwise they can end up looking like a dense mass of green. I always look at tree subjects with one eye closed. This enables me to see trees as they would appear were I to paint them. If, looking at them with one eye, the foliage appears as one big mass, you have to find a way of creating recession, by changing the tones and colours, so that one layer of foliage sits behind the other.

The texture of the foliage will vary from tree to tree. The texture of a silver birch's foliage is vastly different from that of a cedar of Lebanon, which again is different to a Scots pine. Suffice to say that the marks you make with your brush should be in sympathy with the character of the foliage. In the oil sketch 'The Woods, Talbot Village' I have painted the pine tree trunks and foliage in slightly different tones. There is more contrast in the nearer ones, while those in the background are softer. The texture of the foliage – clumps of needles – is largely horizontal in character and the brushwork reflects this. Compare this with the more 'blobby' character of the undergrowth foliage and the vertical marks used for the rough grass. The sandy path, still with its carpet of last year's autumn leaves, is more linear and only slightly broken.

In the watercolour 'A Dorset Footpath', the shaded path contains a considerable amount of texture. Note how dark and textural it is in the bottom left corner and how it lightens and becomes texturally softer as it goes towards the centre of the painting. See how differently I have treated the foliage of the left and right hand trees – on the left, there are dense, broken clumps of foliage, while the treatment of the sunlit right hand tree is finer, being based on an overall underwash overlaid with dry brush effects. Even in the brightly lit centre and background trees, textures have been indicated but applied more softly as detail, colour and tones become more subdued with distance.

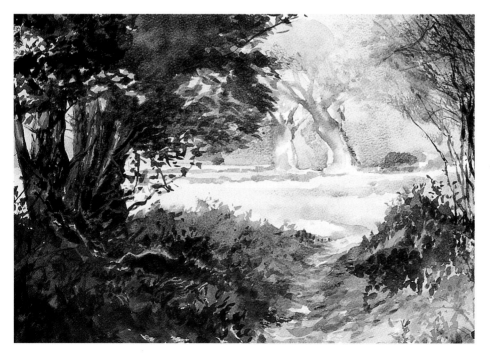

LEFT A Dorset Footpath; Tony Paul
Watercolour, 279 x 380 mm
(11 x 15 in)

WATER IN LANDSCAPES

Water, being fluid, reflective and often transparent, is capable of taking on almost any colour or texture, so much depends on its location, the speed of flow, the light and the weather. There is no single way of portraying water. You will need to look closely at how the water moves and think about how you might approach painting it. Look at its surface: is it giving a mirror reflection? Is its surface broken? Can you see into its depth? Can you see the stream bed?

In the illustrations on this page I will show two different water situations:

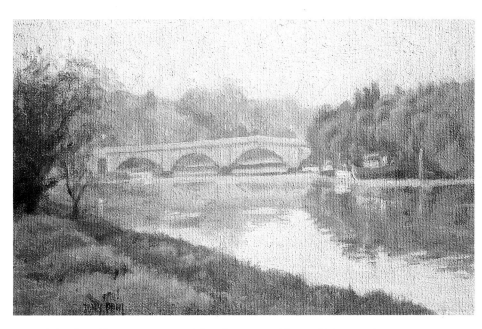

ABOVE The Thames at Richmond, Tony Paul
Oil, 170 x 250 mm (6½ x 10 in)

When looking horizontally across water as in the oil painting 'The Thames at Richmond', the water reflects the colours of the sky and landscape, but a little more darkly as some light is absorbed by the water. This reflection depends on the surface character of the water. The rougher the surface, the less the reflection will be. In this painting the surface is gently rippled, giving a reflection that is broken at the edges.

In the tempera 'Kingfisher', the stream is shallow and the rippling of the water is much more furrowed than in the Richmond painting. One side of the wavelet reflects the brilliant yellow of the landscape, while the other allows the viewer to see through the clear water to the reddish-brown bed of the stream. The final effect is of reflection and transparency.

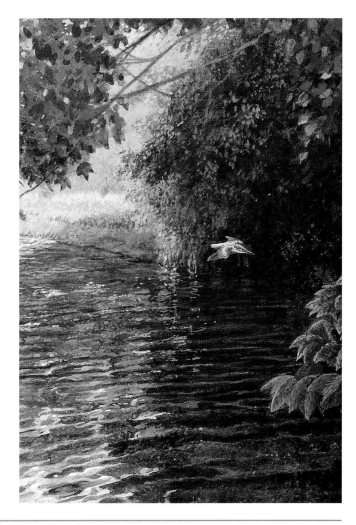

RIGHT Kingfisher, Tony Paul
Egg tempera, 305 x 250 mm (12 x 10 in)

Water, undisturbed by wind or current, will give a mirror image in reflection – the kind of effect that can be seen in a pond or a lake on a very still day. If there is a slight flow in the water or a hint of wind there may be a very slight distortion to the reflection, as in the top illustration. The further the reflection goes from the reflected object, the more pronounced the distortion will be, due to the effects of perspective.

The second illustration shows still water that has been disturbed, perhaps by a passing rowing boat or a duck landing. The distortions of the reflections are more marked and the rounded ripples show a highlighted and shaded side. The wavering may increase with the depth of the reflection and may result in it breaking up. Secondary concentric rippling is likely at the point where the object – in this case a post – enters the water.

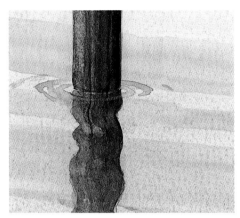

When water has a flow the degree of surface disturbance will depend on the speed of flow, the depth of the water and the character of the river bed. The shallower and faster-flowing the water is, the rougher the water will appear, particularly if the bed over which it runs is rough or rocky. In the third illustration, the water has fairly linear ripples that have a darker shadow side. The reflection, while reasonably solid near the source, will begin to break up as it deepens. The flow will cause a bow wave to be created on the upstream side of the post, while a wake occurs downstream from it.

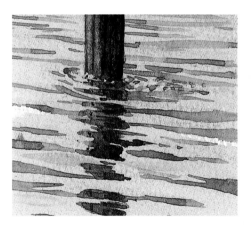

Fast-flowing water, particularly if shallow or over a rough bed, is very linear in texture. The reflection from the base of the source is likely to be broken, often quickly dissipating and vanishing. The bow wave created by the speed of the water is very pronounced and its wake turbulent. Sometimes the wind can ruffle the surface of an otherwise calm surface to give, depending on the direction of light, a stripe of darker tone or sparkling light that will interrupt and override any reflections. These are useful in describing a water surface that is an almost a perfect mirror image.

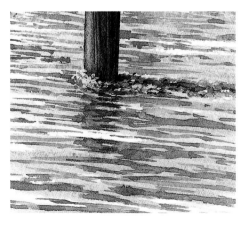

CLOSE-UPS IN DETAIL

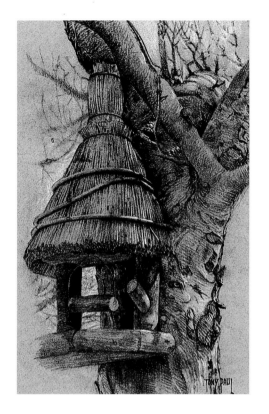

This thatched bird table sits in an old apple tree just outside my kitchen window. I drew it on fawn Ingres paper with a 2B pencil and a white coloured pencil. I was interested in showing the rough textures of the old tree and the smoother thatch. The grain of the Ingres paper broke up the pencil lines unless I pressed fairly hard, but that pleased me as it helped with the character of the textures. I used the colour of the paper as the mid tone, the white pencil providing the lights and the black pencil the darks. Generally, the marks I made were lines – sometimes cross hatched, sometimes parallel – to create a sense of form. I leaned on or pulled back the pencil as required to make stronger or more diffused lines.

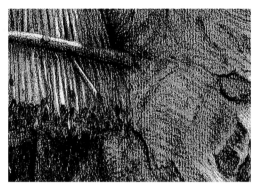

LEFT Close-up of detail

LEFT The Bird Table; Tony Paul
Pencil and coloured pencil,
305 x 225 mm (12 x 9 in)

There is a wealth of texture in the watercolour and gouache 'Bathing Robin'. After drawing the subject, a texture was first sponged over the paper avoiding the areas of the puddles, using a browny-grey colour. The open textured sponge suggests stone shapes and I used and developed these 'happy accidents' with some shading and highlights (see detail). I softened the colour and sponged more lightly over the upper areas to imply distance. The water, with its ripples and reflections, was painted around the robin, and the grasses, leaf and stones were refined and heightened with white gouache paint.

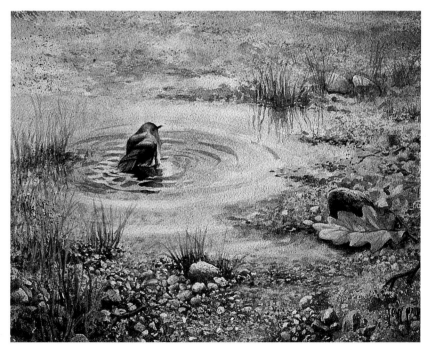

ABOVE Bathing Robin; Tony Paul
Watercolour and gouache, 228 x 305 mm (9 x 12 in)

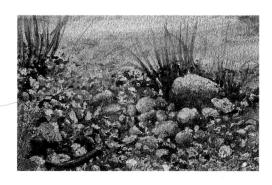

LEFT Close-up of detail

A Landscape in Pastel

(A rough meadow, full leafed summer trees, sheep and the 'C'-shaped area of light are the elements that attracted me to this subject. I liked the contrast between the shaded and sunlit trees and grass and the sense of distance. I thought that pastel would be a good medium for the subject, being perfect for capturing the textures of the meadow and dense tree foliage.

Stage 1

I drew the subject on to a buff coloured paper, being careful to get the proportions of the various elements correct in relation to one another – see the blue arrows. Once this was in place I started with the sky, working it in with a soft blue, with cream and white clouds. The blue was blended carefully with a finger to give an even texture but the overlaid clouds were left as applied.

Stage 2

The next stage was to rough in all the elements of the composition using approximate colours. At this stage, the actual colours aren't too important as they are likely to be modified in the final stage, but I was careful to get the tonal relationships fairly close to how I wanted them. If you look at this stage with half-closed eyes, you can see that already there is a feeling of direction of light.

Stage 3

Working layer over layer, the modelling of the trees, shadows and meadow grasses was refined. See how the soft purplish colour put into the trees implies shadow, but shadow with light within it.

The far edge of the sunlit meadow is now almost white and the sheep were put into the edge of the meadow's shadow. Various light and dark colours were interwoven to create the textures and colours of the near, shadowed area of the meadow. The final touch was adding the light coloured seed heads.

The textures within the trees are based on simplifying the foliage into areas of tone, irregularly broken into by other tones to achieve a good representation of light. The purplish colours within the foliage, as well as providing a foil to the green, give a sense of recession and volume to the trees.

BELOW Dorset Landscape; Tony Paul
Pastel, 407 x 508 mm (16 x 20 in)

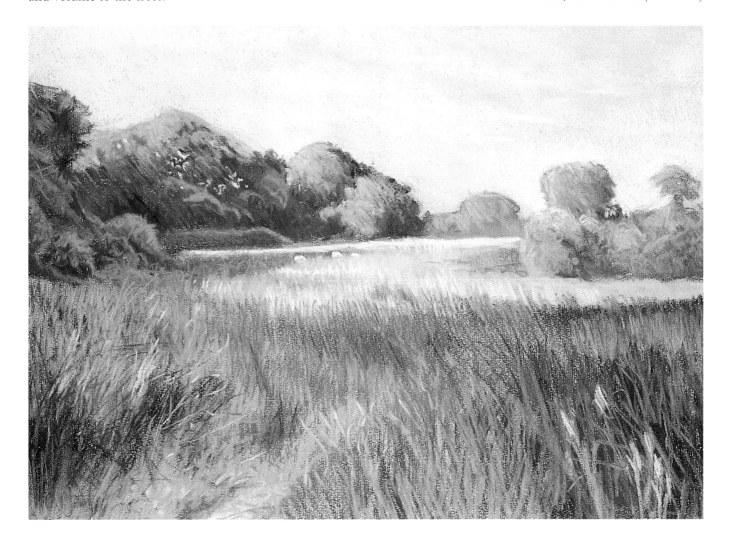

A Landscape in Oils

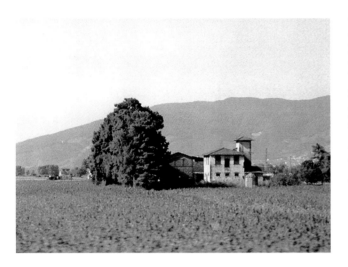

While tutoring in Tuscany I was en route by bus from Montecatini Terme to Lucca for a day's painting when I spotted this typically Tuscan farmhouse. I quickly took up my camera and snapped it. I loved the boxy house and its tower, with the barn behind it, the backdrop of the soft purplish mountains and the lush green of the fields and trees. When the photos were processed I was, as usual slightly disappointed. Somehow the photo didn't convey the heat of the July sun, so I knew that I would have to change things to get this over in the painting.

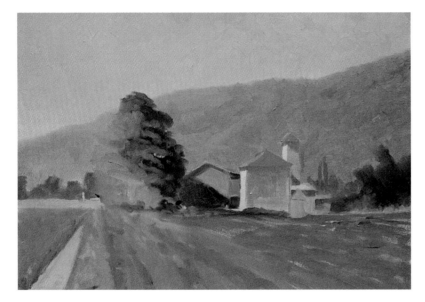

Stage 1
I blocked in the basic features of the landscape over the red ochre tinted board, keeping the colours clean and fresh. Having roughed this in I worked into the cerulean blue sky, adding a purple of the same tone at the top and Naples yellow near the mountain edge. This created the slightly mottled texture that I had sought and created a sense of heat. The mountains needed little change. The dull purple was scrubbed on to give some thick and thinner areas where the red ochre priming showed through. I added some of the greens used in the field.

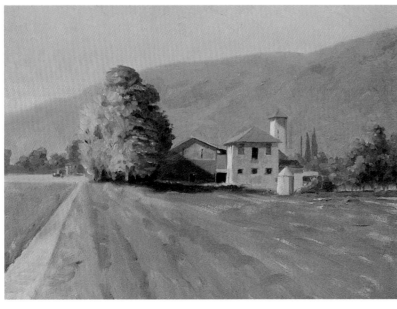

Stage 2
Working on the central area of the painting, I tackled a band of trees and the buildings. I was careful to create a sense of distance by varying the temperature of the colours used for the vegetation. You can see that the trees to the immediate right of the tower are in the far distance (I added the cypresses to enhance the Tuscan theme), while those on the left of the large bank of trees by the buildings are a little closer, and those on the right of the painting closer still. Details of windows and shadows were added to create form into the buildings.

Stage 3

I was interested in the way the crops in these fields are usually grown in serried rows. I liked the perspective effect that these rows created. As can be seen from the reference photo, the angle of the shot didn't reveal the rows, appearing more as a solid mass of vegetation, so I imagined how they would look and painted them in. Besides green, I was careful to add other colours such as pink, yellow, blue and purple within the rows to maintain the impression of a direction of light. Finally I went round the painting touching in detail and refining areas that, perhaps, looked a little clumsy.

BELOW Tuscan Landscape; Tony Paul
Oil, 381 x 457 mm (15 x 18 in)

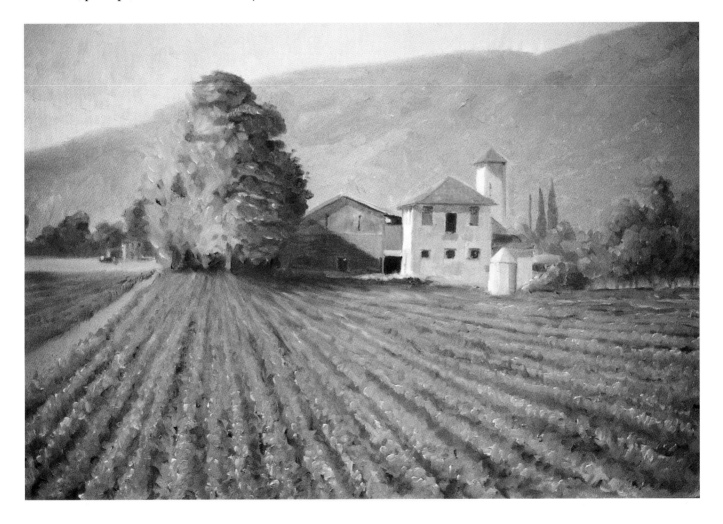

The emphasis in Gregory Davies's 'Reflected Clouds, Tarn, France' is very much on the sky as seen reflected in the river. The painting is full of light with smoky purplish shadows within the trees. Compare the textures of the water, the trees and the near rushes, each giving the character of the subject while retaining a unified, painterly technique, with colour applied over colour, creating a shimmering surface.

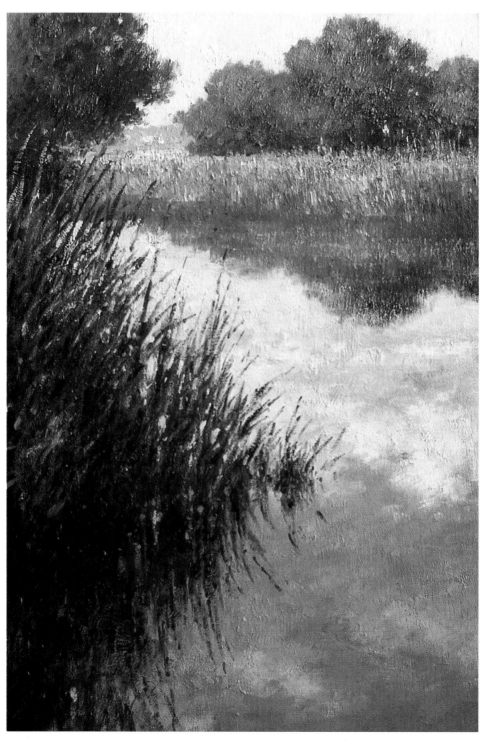

ABOVE Reflected Clouds, Tarn, France; Gregory Davies
Oil, 762 x 610 mm (30 x 24 in)

PART THREE
TEXTURES IN STILL LIFE

ABOVE Still Life with Egg, Tony Paul
Egg tempera, 357 x 254 mm (14 x 10 in)

GLASS

Clear glass is very difficult to paint, simply because of its transparency. In Ronald Jesty's brilliant watercolour 'Gin and Tonic' we can see how effective good observation can be. If we take the clear bottle it is the distorted shapes within its base, the slightly darker tone within the bottle and the distorted table edge near the surface of the tonic in the bottle that tell us it is clear and filled with liquid. Coloured glass is easier to portray simply because it has colour, but care has to be taken with tones so the appearance of transparency is maintained. I love the colour that has been put into the cast shadows and the textures within the cloth.

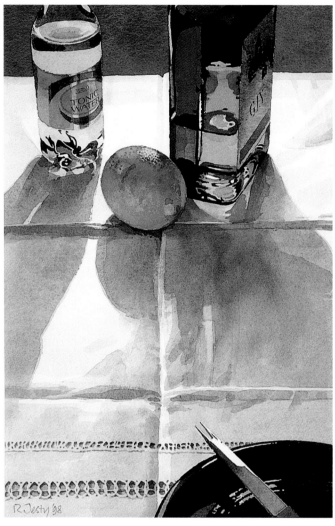

RIGHT Gin and Tonic, Ronald Jesty
Watercolour, 368 x 241 mm (14½ x 9½ in)

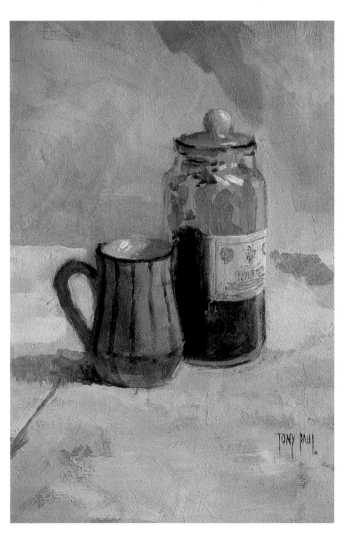

In the oil sketch 'Pigment Jar and Mug' I was interested in the contrast between the opaque mug and the transparent glass. The transparent glass is marginally darker than the background that we can see through it. There are light reflections from its shoulder and, where the jar curves, it darkens as we look through the thicker glass. You will note that the raw umber pigment is set back from the edge of the jar, thereby showing the glass's thickness. The semi-translucent polythene stopper has an entirely different character.

LEFT Pigment Jar and Mug, Tony Paul
Oil, 305 x 203 mm (12 x 8 in)

CERAMICS

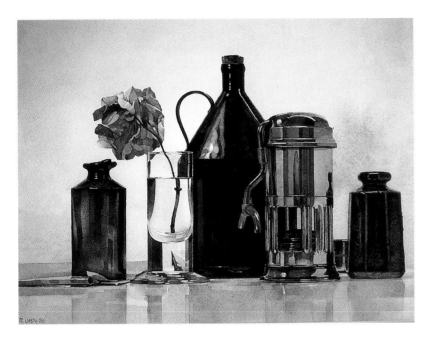

'Still Life with Hydrangea', by Ronald Jesty, shows three pottery jars with two glass items. What is interesting is the subtle way the surface texture of each of the pots has been described. The differences are very subtle. The large black flagon has the most glossy finish, indicated by the sharpness and clarity of its reflections. Almost as reflective is the left hand jar. We can see the flagon and the glass dully reflected in its side. The dullest surface is the hexagonal pot on the right, which has hints of reflections from its sides but nothing is distinct or sharp edged.

LEFT Still Life with Hydrangea; Ronald Jesty
Watercolour, 303 x 457 mm (12 x 18 in)

In the egg tempera 'Honesty', after completing the drawing in ultramarine paint I sponged over the whole panel in several layers to make the background colour. The drawing still showed through and I worked on the cloth and pots, adding white to the colours for the lighter areas and using translucent colour for the darker areas. Here and there the background colour has been left within the pots and the cloth. This reads as reflected light.

Sharp accents of light on the vase contrasting with clean edged darks tell us that the glaze is glossy and light-reflective – it is important that the absolute highlights read against the 'white' of the items. The reflected lights in the shadow area of the Chinese bowl and the bright light inside it tell us that this too is glossy. The satiny texture of the honesty, with its bright highlights that soften into cool lilacs, ochres and cerulean blues were a delight to paint.

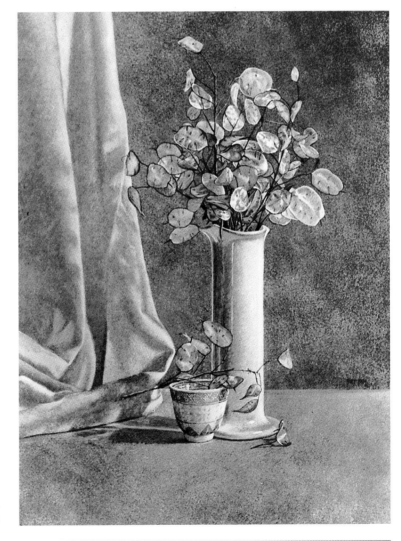

RIGHT Honesty; Tony Paul
Egg tempera, 457 x 356 mm (18 x 14 in)

METALS

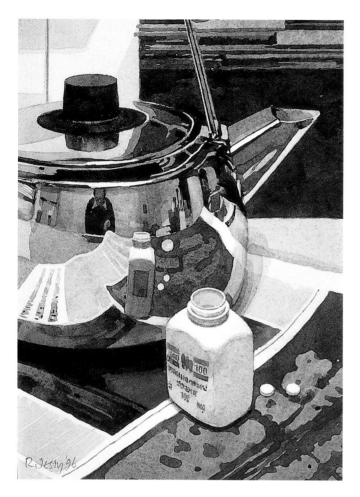

The look of metal will vary according to the fineness of its surface. Satin finish steel will have a very different surface quality to that of polished steel. In his watercolour 'Dissolve Two Tablets in Warm Water', Ronald Jesty has shown the mirror effect of the polished chromium of the kettle. It is the sharpness of the reflections in the kettle's surface and the reflections of pure, white light that describe its smooth texture. We are even treated to a self-portrait of the artist at work within the reflection. Note too, how he has been careful to recreate the distortion of the reflected images, thereby describing the form of the kettle. Beyond the representational excellence of the image, the texture of the watercolour paint itself is superb, with a lovely granular quality.

LEFT *Dissolve Two Tablets in Warm Water; Ronald Jesty Watercolour, 285 x 203 mm (11¼ x 8 in)*

The oil 'Clay, Copper, Brass and Glass' was painted as a demonstration for one of my classes. It was an exercise in contrasting the surface qualities of earthenware, glass and metal. Neither of the metal items is highly polished as they once were. Of the two items, the copper jug is the duller one, the once highly reflective surface now has a bloom that hints at green-grey. We can compare the textural character of the unpolished inside of the brass pot to the reflective outside. Careful observation is needed to capture the colours of the reflections against the true colour of the reflected items. The colour of the metal (unless white metal) will influence the reflected colour.

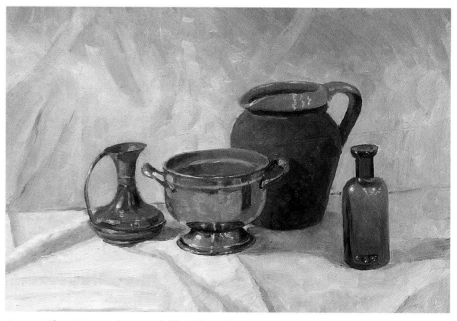

ABOVE *Clay, Copper, Brass and Glass; Tony Paul Oil, 315 x 430 mm (12½ x 17 in)*

FRUIT AND FLOWERS

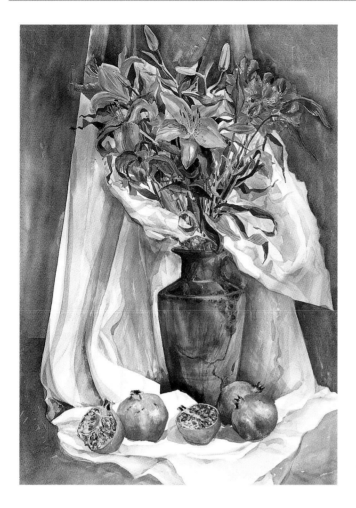

Frances Shearing's painting 'Lilies and Pomegranates' contains a wealth of contrasting textures: the matt surfaced cloth against the dully reflecting vase and the delicate flowers against the leathery skin of the pomegranates. Notice how the lilies are lighter in tone than their background, which helps them to stand out, and how the shapes of the individual petals have been described in terms of the colour becoming lighter and darker. The white paper surrounding the flowers is subtly different to the white draped cloth behind the vase. It has a crinkly texture with sharper, smaller creases, whereas the drape's creases are softer and more flowing.

LEFT Lilies and Pomegranates; Frances Shearing
Watercolour, 559 x 381 mm (22 x 15 in)

In Hilda van Stockum's painting 'Still Life with Pears' we can see how oil paint has been used to represent the varying textures within the subject. See how the surface quality of the jug changes from the glazed part to the earthenware. Note, too, the dull reflection of the screen in the table and the reflection of the cloth's creases in the underside of the bowl – the only clue that the bowl has a shiny surface. But the stars of the show are the pears. The mottled surface textures, finely painted, have really caught the nature of the fruit. Warm and cool colours have been used in both the lighter and darker areas to give form to the pears and the reflected light – best seen on the extreme right hand pear – has put cool light into the shadows. Tonal counterpoint has been used effectively to make the pears read against one another and the highlights are soft-edged, compared to those on the jug.

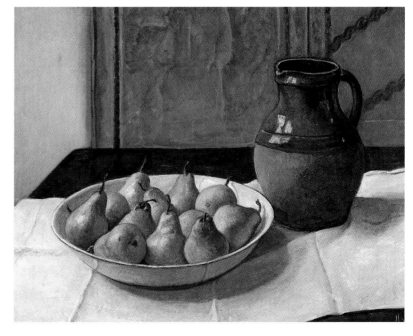

ABOVE Still Life with Pears; Hilda van Stockum
Oil, 305 x 406 mm (12 x 16 in)

CLOTH

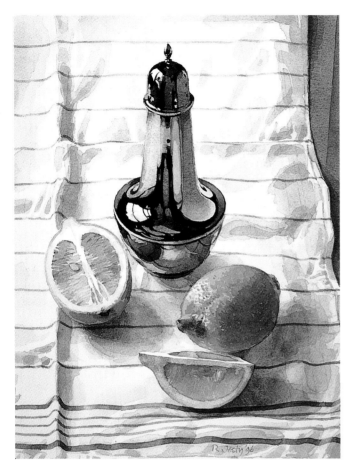

The eponymous objects in Ronald Jesty's 'Sugar Caster and Lemons' are beautifully rendered, but I really love the effective simplicity of the painting of the cloth. The angle of the light has helped to give the cloth form. The ridged creases and the stripes create a structure and imply perspective while the minor creasing and undulations say a lot about the character of the cloth itself. With much of the paper left unpainted, the cloth has been modelled by employing pale washes of a purplish character. Interestingly, these seem to have a warm orangey undertone (perhaps a mix of violet and yellow?). Subtle modelling with very pale washes is juxtaposed with ones of firmer tone, particularly in the shadows cast by the fruit and caster.

*LEFT Sugar Caster and Lemons; Ronald Jesty
Watercolour, 311 x 241 mm (12¼ x 9½ in)*

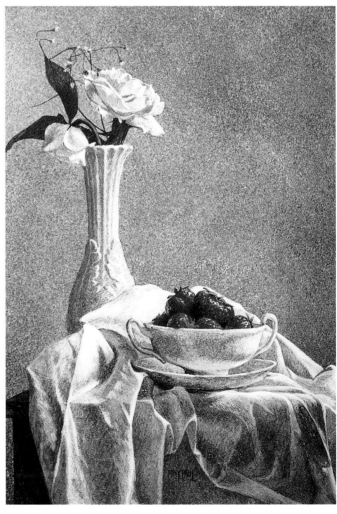

In the egg tempera 'Strawberries', I wanted to contrast the hard textures of the ceramic items with the fleshy fruit and the soft, folded translucency of the cloth and the rose. With small multi-coloured brush strokes I tried to convey the effect of light on the cloth. I was particularly interested in the contrasting lights that occur in such a creased up piece of material. I played with the different lights that I found: the direct light shining on the material; the light shining through it and the reflected light. The shadows are largely cool in character but in parts have warm undertones.

*RIGHT Strawberries; Tony Paul
Egg tempera, 305 x 203 mm (12 x 8 in)*

A STILL LIFE IN WATERCOLOUR

Ronald Jesty has chosen a complex subject of varying textures for his watercolour 'Persimmon and Plums'. The light on the subject comes slightly from the right, casting soft shadows. The warm reds, oranges and browns are countered by the dark blue green of the tall pot.

Stage 1

After completing the drawing, the background washes were painted, leaving the objects as white paper. He put some anemones in the mug and blocked them, and some elements of the fruit, in. At this point there is no attempt to 'finish something off'. Some elements of the painting will be brought to a finish in the next stage. The washes applied so far have an interesting granular quality. Note that he has painted some shadow colour on to the pestle and mortar and some of the fruit prior to applying the colour.

Stage 2

The anemones and mug, persimmon, pestle and mortar, the book and the plums are modelled to completion, while the vase and box are blocked in awaiting further work. It is interesting to note that he has changed the lighting slightly, bringing it round to the left so that shadows are cast to the right, rather than the left of the objects. The texture of the plums' skin is perfect, the dull reflective surface indicated by soft, bluish reflections that contrast against the sharper reflection from the pot.

Stage 3

The duck egg and rich deep blues of the pot are painted in, the sharp highlights carefully preserved and the reflected red from the anemones indicated. The decoration around the neck is detailed and the lip worked to give a realistic effect. Most of the painting has now been brought to a finish. The box, already underpainted, is overlaid with a broken wash of deeper brown, the detail of the dovetail joints being added when this was dry. As the shadows of the striped cloth were applied in the last stage, all that remained was to carefully paint in the stripes, reinforcing its undulations. The last items to be resolved were the dried flowers, which were simply finished in two layers, the first applying the lighter colours which, when dry, were detailed over using darker paint applied with a small brush.

Watercolour, in good hands, is capable of representing texture wonderfully well. In this painting we have all kinds of textures – the non-reflective surfaces of the box, the cloth and the book; the slightly reflective surfaces of the plums, the eggshell surfaces of the pestle and mortar; the semi-reflective persimmon and anemone buds; and the highly reflective glaze of the pot, all beautifully demonstrated.

BELOW Persimmon and Plums; Ronald Jesty
Watercolour, 407 x 508 mm (16 x 20 in)

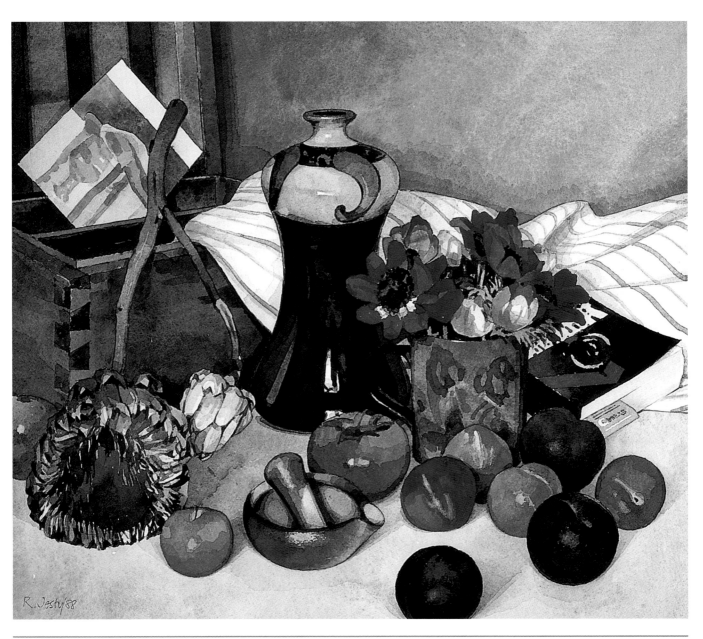

R. Jesty 88

A STILL LIFE IN EGG TEMPERA

The important aspect of this subject is the fall of early evening light coming in through the window. I liked the way it cast shadows and worked on the textures of the soup bowl, the wedges of floured bread and the lace tablecloth. The detail involved made it an ideal subject for a tempera.

Stage 1

I used a pristine white gesso panel, cracked an egg and blended the egg yolk with pigment and water to make paint. I then went on to draw the subject in ultramarine blue. Then I sponged several layers of very diluted colour over the drawing – first ultramarine, then raw sienna, then iron oxide red – there was no white added, so the drawing showed through.

A few minutes later, when this was dry I worked in the shadows in stronger ultramarine using a 'ruined brush'. Where I wanted the shadows darker I added a little Indian red to make a dull purple. For the dark behind the chair I again painted in layers, but this time more densely – first viridian, then alizarin crimson followed by ultramarine. Finally I used the slightly translucent zinc white to put in the strongly lit areas.

Stage 2

I darkened the left hand side and foreground of the tablecloth to increase the contrast with the light patch, cooling the colour as it came forward, then worked on the rich brown-red of the chair. When completed I moved on to the bowl, plate and cutlery, picking out their edges and reflections in titanium white – a very dense white – and added the green patterns on the pottery. I put more colour and strength into the shadows and developed the bread board and bread wedges.

I then began to put in the lace tablecloth. I knew that it was white but, against the brilliance of the light patch it looked darker, so I made it a subdued greyish colour. You can see how I worked the pattern in the area at the bottom. First I drew the basic structure of the pattern with a fine line, then worked the lace effect over this 'scaffolding'.

Stage 3

I continued my work on the tablecloth, suggesting the mesh of the lace between the thicker patterned areas with cross hatched strokes. This was not done rigidly, its broken effect implies a slight wrinkling of the cloth and gives a more lively result. Where the pattern was within the sunlit area I applied it with pure dense titanium white.

I moved on to the bread and bread board, refining their forms and working the colour in translucent dabs to create the crumbly texture of the soft bread. I had to be careful to maintain the difference between the light from the window and the 'white' of the textured bread. Being against the light it is in shadow and, no matter how white you *know* it is, it will always *appear* darker than the sunlit part of the table.

I felt that in some parts of the tablecloth the raised pattern looked a little flat, so I added shadow here and there to emphasize the pattern and make it stand away from the thinner mesh. Finally, I worked on the floured crusts of the bread in various strengths of titanium white and added some richer reddish accents to the edges of the crusts.

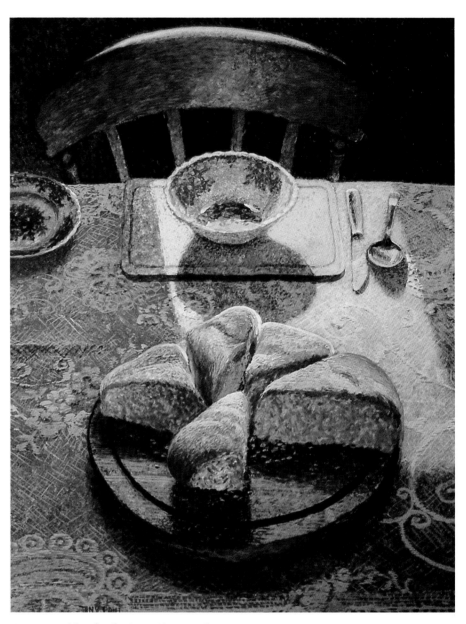

ABOVE *Waiting for the Soup*; Tony Paul
Egg tempera, 406 x 305 mm (16 x 12 in)

PART FOUR
TEXTURES IN PORTRAITS

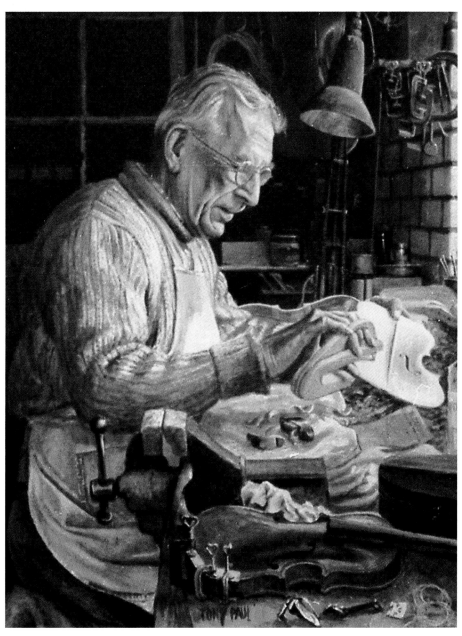

ABOVE The Violin Maker, Tony Paul
Acrylic, 254 x 203 mm (10 x 8 in)

SKIN TEXTURE

Family characteristics, age, occupation, temperament, illness, race, weight and sun can all affect the texture of the skin. Even identical twins, one of which goes into banking, while the other becomes a fisherman, will end up with totally dissimilar complexions.

The colouring of the skin will vary too. There is no such thing as 'a' flesh colour. Compare your complexion to that of your friends and family and the chances are you will all have different skin colours. Look at the palm of your hand, now turn it over and look at the back – more than likely the colouration will differ. The colours at the top show some typical Caucasian skin colours. The top row shows skin receiving light while the row below shows the same skin colours in shadow. Additionally, the texture of the skin will change as we age.

In Figure 1 we see the face of a young child. The skin is tight and the features understated. Painting portraits of babies or toddlers is difficult because the forms are so slight and subtle. The very young are often chubby. This adds to the flattening of form and can lead to a bloated appearance. Monet's 'The Artist's Son Asleep' (1867–68), a painting of a child in slumber with a greenish-grey upper face and bright red cheeks and lips could only be appreciated by a fond parent!

Figure 1

As we get older other factors come into play. By the time we reach our thirties, lines begin to form that often give an insight into our character. The severe looking self-portrait in Figure 2 is of me aged 59. The harsh lighting has emphasized the forms in my face but I cannot deny the sagging skin under my eyes or the creases in my forehead. I am pleased to see the laughter lines though, despite my rather stern glare (don't self-portraits always glare?). I enjoy an active sense of humour.

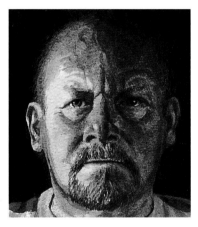

Figure 2

In old age (Figure 3), the skin often thins and wrinkles, sometimes appearing paper thin. Folds in the skin become deeper and often the colours in the face change, turning greyish or sallow and sometimes reverting to the delicate colouring of a baby.

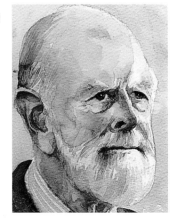

Figure 3

When working on a portrait don't get too carried away with the wrinkles. They can be seductive but if exaggerated only slightly will age the sitter considerably. It is best to look at the sitter through your eyelashes. This puts the head into tone and much of the fine detail is lost. The lines and creases that you can see while doing this are structural and must go in. The ones that disappear are superficial and can be left out.

YOUNG SITTERS

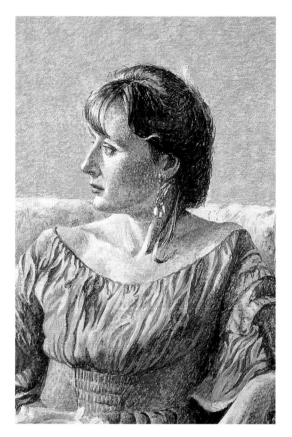

In this detail of a woman in her twenties, her complexion is clear and the skin around the eyes and mouth is firm. The light strongly models her face and the changes of plane are well defined. While strong lighting effects can be used on the young, using them on the older sitter can age him or her considerably. The neck is another giveaway as we age. You will note that Niki's neck is smooth and unwrinkled.

Egg tempera was used for this portrait, which I applied as small touches, often of varying colours. The small touches blend in the eye to create an impression of a single colour. This technique is used throughout the painting.

LEFT Niki (detail); Tony Paul
Egg tempera

Painting a portrait in watercolour is difficult. Painting a young sitter in watercolour is doubly so. Dried edges of watercolour can imply creases or sharp changes of plane, and several wash overlays can make the sitter look quite wrinkled. In my portrait of Lynsey, I used my customary underwash mix of Indian red and ultramarine to model the tones of the head. Once dry, it left me free to overlay the face with pure, transparent colour washes without the need to worry about their tone. Although the washes do have edges I don't feel that these destroy the smooth and taut character of her skin.

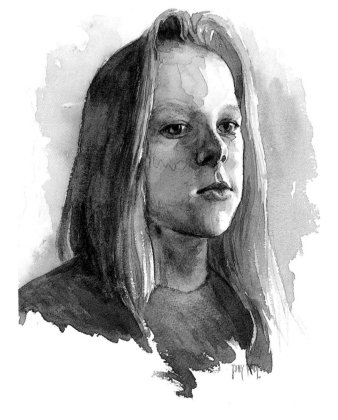

RIGHT Lynsey; Tony Paul
Watercolour, 297 x 210 mm (11¾ x 8¼ in)

MIDDLE-AGED SITTERS

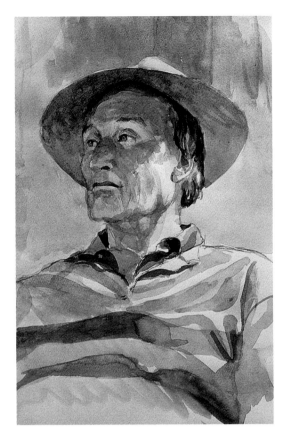

Watercolour is much easier to use with older male subjects. The cartridge paper of the sketchbook tends to draw the paint into the surface, so you often end up with more lines than you want. I found this an advantage in this particular study as the forms and lines of Brian's features almost made themselves. The light coming through the window lit his cheek and also fell on the newspaper on his lap, reflecting back up into the shadow areas of his face, lightening the area under his eyebrows and nose. This reflected light greatly helps the creation of form in this area.

The texture of the skin shows signs of sagging along the jawline, the neck, the forehead and around the mouth. Small, broken washes of watercolour have helped to give the impression of ageing skin.

LEFT Brian; Tony Paul
Watercolour, 280 x 195 mm (11 x 8 in)

This small oil sketch of Richard was painted on a rough primed board tinted with a blend of raw and burnt sienna. With oil paint, after making a light drawing of the subject in diluted paint, I like to go for the lights first, and then put in the dark accents. The tinted board acts as a mid tone. Even though the painting was hardly underway, the portrait started taking on a three-dimensional quality and already had a sense of his age. His strongly lit left eyelid and the dark line of the eye socket, along with the separation between the highlight under the eye and that on the cheekbone all combine to suggest creasing, while the dark shape of the bag under his right eye and the creases on both sides of his face above his moustache hint at sagging flesh. I have kept the brushmarks lively and their texture hints at modelling in areas such as the forehead.

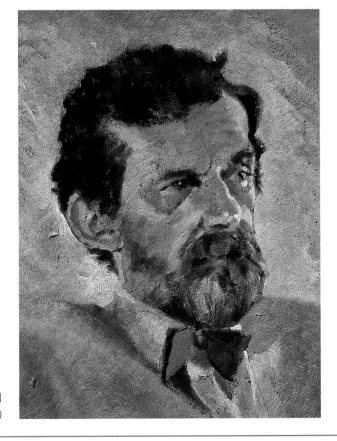

RIGHT Richard; Tony Paul
Oil, 250 x 195 mm (10 x 8 in)

ELDERLY SITTERS

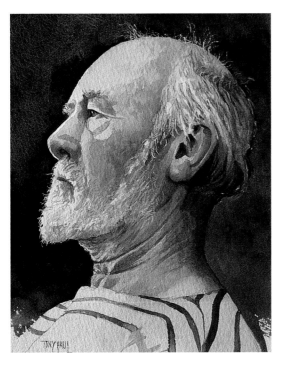

In this watercolour of Tony G several clues give away the age of the sitter. The skin above his eyes has sagged so much that they have become hooded, with deep creasing, and the bags under the eyes are deep and rounded. Adding thin highlights next to darker lines, taking account of the fall of light, will help suggest deep lines.

The skin looks uneven and mottled with hints of purple and red. This was achieved by using touches of dry brush or even by sponging, if the painting is to be very detailed. The hair is white and thinning and the skin of the neck is wrinkled and leathery in appearance – again, a highlight next to a dark line will deepen creases.

LEFT Tony G; Tony Paul
Watercolour, 380 x 280 mm (15 x 11 in)

This rather sad portrait is of my father a short time before his death. He had retired into his own world and I tried to suggest this in the pose. He had worked outdoors all his life and his skin was tough and leathery, with a weathered ruddy colouration. Upon his descent into dementia he lived indoors and as a result his skin softened in colour and became blotchy and greyish. I used sponging and some lifting off to achieve some of the textures.

However, certain areas of his face retained their colour – mainly his nose and cheeks, largely due to broken veins which were blotchy in character. I liked the way that the light shone through his ear and used a bright orange mix edged with white to represent it. The textures within the shirt and cardigan were achieved by applying detail over underwashes.

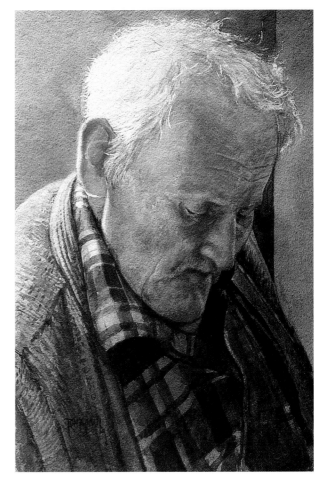

RIGHT Artist's Father; Tony Paul
Gouache, 330 x 254 mm (13 x 10 in)

AFRO–CARIBBEAN

Like any human skin, black skin is rarely a single colour, but will change depending on what area of the face and body it is. Black skin has similar textures to that of other races, depending on age and exposure to weathering.

Generally speaking – and with the melting pot of the human race one can only talk in general terms – the things that will give the character of the Afro-Caribbean will be as much in the structure of the head as in the colouration. Indeed, if I had made a line drawing of this girl with no tone to indicate her colour, you would certainly be aware of her race.

In this portrait I have used the colours that I can see in black skin. A tan made of raw and burnt sienna was used around the nose and cheeks, manganese blue on the forehead, a mix of ultramarine and Indian red in the shadows, the jaw and the front of her neck and phthalo green at the back of the neck.

When Afro-Caribbean skin reflects light, the reflections look bright in comparison to the darkness of the skin, the skin usually has a very dry-looking velvety texture with high-lights that have a bloom of soft blue or green. That kind of bloom can be seen in the portrait, particularly evident in the neck. In the portrait the girl has straightened hair. Typically Afro-Caribbean hair – even when straightened – is usually denser than other types of hair and if left in its natural state has a distinctive texture that can be achieved by sponging or dry brush techniques.

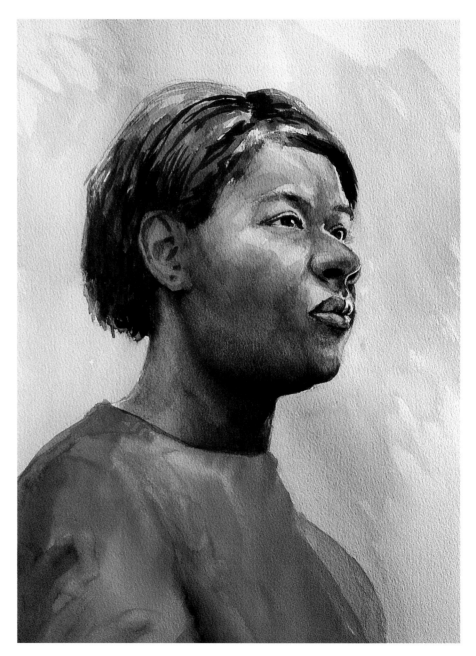

RIGHT Portrait (study); Tony Paul
Watercolour, 560 x 380 mm (22 x 15 in)

ASIAN

My acrylic painting of Nagababu was painted on a rough primed board. This rugged surface has helped to give the applied paint an interesting broken quality. Brushmarks, too, have been important in the portrayal of texture. If you look at his hair you can see that they emphasize that it is fairly straight and well groomed. See how different the brushmarks of the moustache are: more random in direction and less glossy.

The skin colours are quite muted and cool, with soft tans made from burnt sienna and phthalo green lightened with white and a soft, dull purple made with quinacridone burnt orange, ultramarine and white. I also used raw umber, lightened with white and sometimes warmed a little with raw sienna.

The warmest colours – which is common to most racial types – appear in the lips and ears – the deeper colour in the ears is the quinacridone burnt orange / ultramarine mix, but with a touch of white added. It is interesting to note that the upper and lower lips are of distinctly different colours. The upper lip has the ear colour mix, but with more blue added while the lower lip is the burnt orange with a little of the upper lip colour in shadow areas. The chin area is a greyish colour – a fairly equal mix of burnt sienna and ultramarine.

The skin had a fairly matt, dry look and this dryness means that the light reflected from his white shirt on to the underside of his chin is softly stated.

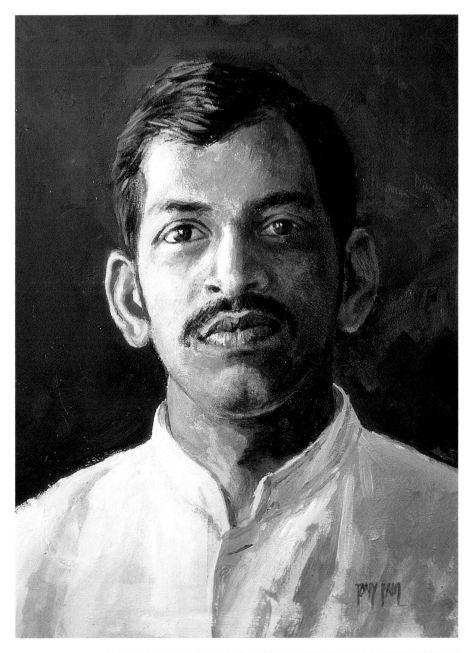

RIGHT Nagababu; Tony Paul
Acrylic, 330 x 254 mm (13 x 10 in)

ORIENTAL

When painting ladies I prefer to use a medium that is reasonably smooth and sympathetic. In the case of my portrait of Tania I used gouache with a light touch.

As with the Afro-Caribbean, much of the Chinese racial character is in the structure of the head rather than in the colouration. In fact, when I was looking at oriental people in preparation for this section of the book, I found that there was very little difference in colour to Caucasian nationalities.

The background was applied first so that a mid tone was established, covering the harsh white of the watercolour board and leaving the figure as a white shape. I always find it difficult to judge tones in a portrait worked against a white background, often making them too pale and later, when the darks go in, I have to revisit and strengthen the earlier work. It is much better to pitch the tones right from the start.

I left the highlights of the face as white paper and worked on the hair first, mixing a grey from a diluted mix of ultramarine and burnt sienna. This gave me my greatest contrast – the lit edge of her face against the shadowed edge of her hair.

Having dealt with the lights and darks I could deal more easily with the middle tones of the shadowed side of the face, which was roughed in with a mix of a greenish raw umber blended with raw sienna and applied thinly. While still wet, I dropped in a small amount of alizarin crimson in the cheek area and on the end and underside of the nose. A warm mix of cadmium red and cadmium yellow was washed lightly into the top of the forehead and the lips, and the form of the eyes were painted with alizarin crimson, ultramarine and white. The cool shadow on the far cheek is of pure alizarin crimson applied as a pale wash.

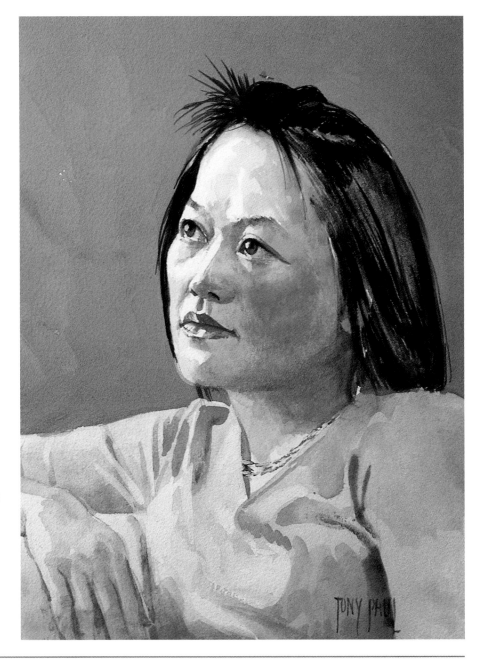

RIGHT *Tania*; Tony Paul
Gouache, 305 x 228 mm (12 x 9 in)

CLOTHING

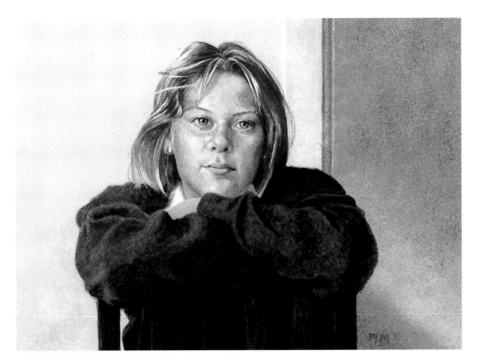

ABOVE Dominique; Tony Paul
Egg tempera, 507 x 600 mm (20 x 23½ in)

Clothing is often not considered as carefully as it should be, and it must be remembered that a painting is only as good as its weakest link and any weakness in the portrayal of the clothing will reflect on the overall impression of the work.

With clothing, the textures of the garments are often very important. Take, for instance, my painting of Dominique. She is wearing a woollen jumper with a distinctive 'nubbly' character. The thickness and stiffness of the fabric will have a bearing on how the material folds and hangs, so it is important to look carefully and to make its representation as important as the face.

In this case the knitted jumper was soft and, because of its thickness, the creases were somewhat rounded. The outer edges of the jumper were softened against the background to imply a fluffy surface. The areas receiving light were more yellow than the shadow areas, but even in these I put a purplish reflected light that was a touch lighter than the darkest shadows. I think that I have achieved the look of the soft, thick material.

Compare this to the shirt of 'The Cobbler'. The medium-weight white cotton is obviously a thinner material, the creases are sharper and there are small cross creases that tell of the comparative thinness of the fabric. Again I have used reflected light in the creases, of a pewterish grey that isn't quite as dark as the deeper shadows. His waistcoat, being of a thicker material, has more rounded creases and his leather apron is slightly reflective, stiff and scarred by superficial cuts.

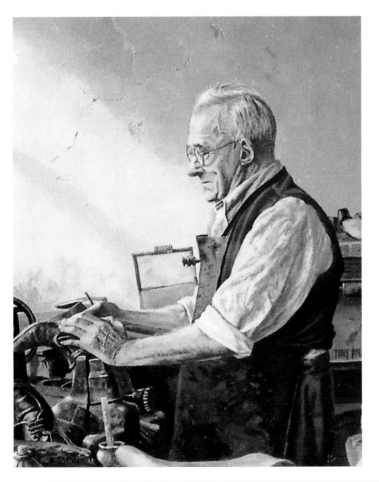

LEFT The Cobbler; Tony Paul
Acrylic, 254 x 204 mm (10 x 8 in)

The poplin of Kerry's blouse, although thin and capable of being creased sharply, as in the edge of the sleeve, generally falls in more rounded creases. Because of its thinness it has translucency, as can be seen on the outer edge of the sleeve, indicated by a change of tone and temperature, from a cool darker tone to a peachy light. Note that where the creases are deep there is a hint of bounced light that tells of the flesh beneath the cloth. The fabric of the skirt is flimsy and naturally creased.

So far we have dealt with matt surfaced fabrics. If we look at the portrait of Kularb we can see how I have represented a shiny satin. With shiny materials the changes of colour and tone are more marked. Where the fabric reflects light it has become pale pink and in the shadows dark and purplish. The bright pinky red is the local, or actual, colour of the fabric unaffected by light conditions. Like the poplin, the material is thin but falls into rounded creases.

ABOVE Kerry; Tony Paul
Egg tempera, 600 x 507 mm (24 x 20 in)

ABOVE Kularb; Tony Paul
Oil, 356 x 254 mm (14 x 10 in)

PORTRAIT IN WATERCOLOUR

You will see from the photograph of Tony G that the subject is lit by a strong directional light. As is often the case with photography, much of the detail that I could see in the shadow areas of the face has been lost, but by peering closely at the photo I was able to bring it through in the painting.

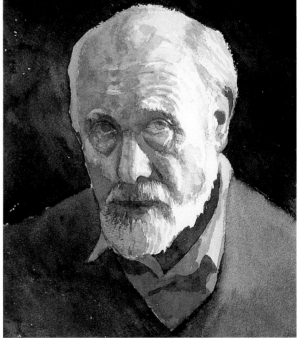

Stage 1

With portraits, I commonly begin by establishing the tones first, even in watercolour. So, using a strong mix of ultramarine and Indian red, I blocked in the background and Tony's jumper, adding raw sienna for the shadowed areas of his shirt. This left the head as a white shape. Changing to a smaller brush, I began working into the shadow areas of his head, watering down the ultramarine/Indian red mix to give softer tones.

From the outset I was careful to try to capture the texture of his skin, overlaying where necessary to achieve darker tones. Even with this first stage a feeling of form is evident.

Stage 2

Having established the basic tones (allowing for the overall tone to become a little darker with the overlaying of coloured washes) I could now work purely with colour without having to worry about gradating its tone. A warm mix of raw sienna and vermilion hue was applied – redder for his ear and cheek, yellower on his scalp and the side of his face – see how its colour changes where it overlays the purplish underwash of ultramarine and Indian red. I used a blue-grey in the shadowed areas of his hair and beard.

Stage 3

The features were refined using a smallish sable brush. The eyes were given more colour and some highlights that I had lost were re-instated with white gouache. Using denser paint, I reinforced the wrinkles of his forehead and the modelling of his cheek and under his eyes. I worked into the beard to give it definition, and added white highlights to his hair and beard. I turned my attention to his shirt, washing over the underpainting with a yellowish glaze and finally darkened the jumper on the left side and added modelling on the right, lifting some of the colour off to lighten it on the edge of the shoulder.

BELOW *Tony G; Tony Paul*
Watercolour, 380 x 280 mm (15 x 11 in)

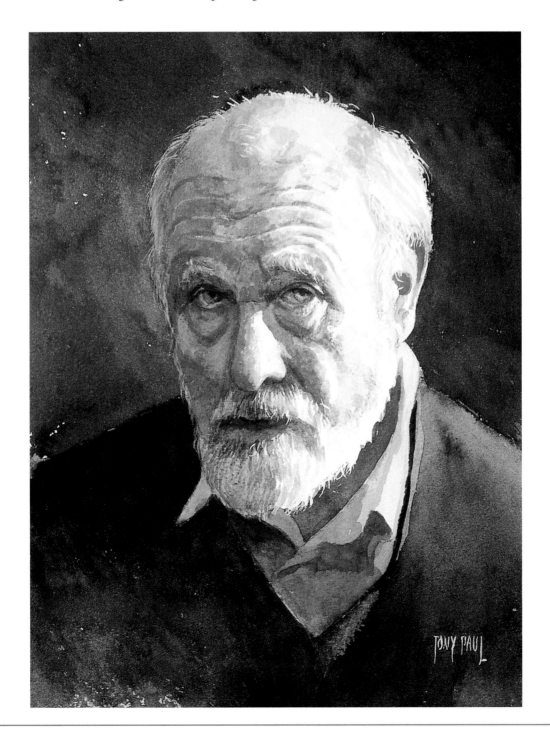

PORTRAIT IN WATER-MIXABLE OILS

The model Joanne was placed so that she had the light coming diagonally from the right. I used a small home made canvas panel tinted with raw umber (an ideal base colour for portrait painting). Water-mixable oils handle in a very similar way to standard oils, but instead of using solvents such as turpentine, water can be used to dilute the paint and clean up afterwards.

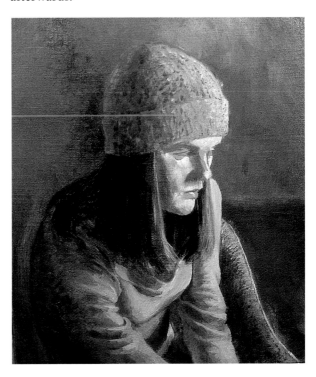

Stage 1

After drawing Joanne in diluted burnt sienna, I laid in the dark tones of the background, making them a little darker than those shown in the photo. Next I began work on the figure, applying the lights first before adding the darks. Some of the middle tone of the panel's priming was left unpainted. Some edges were blended but at this stage the painting was fairly loose in character. The ease with which oils can be corrected gave me more freedom than I had with the watercolour portrait.

Stage 2

In this stage I worked on the figure. I felt that the white of Joanne's top was too glaringly white and would detract from the face, so I chose to paint it a neutral blue grey instead. I modelled the top carefully making sure that the lights and darks worked against one another and that there was a feeling of some reflected light in the shadow areas.

The hair was mapped in with colour and its shapes refined before I turned my attention to the coarse texture of the woolly hat. Again I wanted to create a feeling of solidity in the head. Adding some reflected light at the back of the head, just a little lighter than the shadow colour, turned the form from the side to the back. To finish off I put a little modelling into the cane weave of the Lloyd Loom chair.

Step 3

In this final stage I concerned myself solely with the head, first working on the hat then moving on to the face. As the portrait was painted alla prima, the paint remained wet and I could adjust the modelling, which I did with a small synthetic brush.

I brought more colour into the face and blended the tones to create her complexion. Shadows were softened with flesh colours. Cool, reflected light was indicated on the cheek, while a warmer light reflected from the hair was placed under her chin.

In a young sitter the features are subtle and I had to be careful not to overwork the modelling of her eyes, nose and mouth, which would age her beyond her years. It is amazing how long this takes, with more time spent looking and checking, than actually painting, but it is time well spent.

BELOW Joanne; Tony Paul
Water-mixable oil, 254 x 203 mm (10 x 8 in)

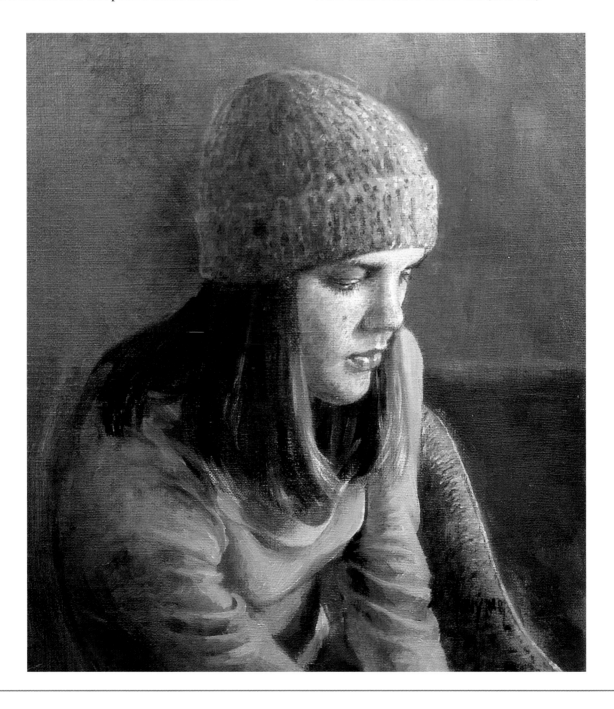

PART FIVE
TEXTURES IN MARINE

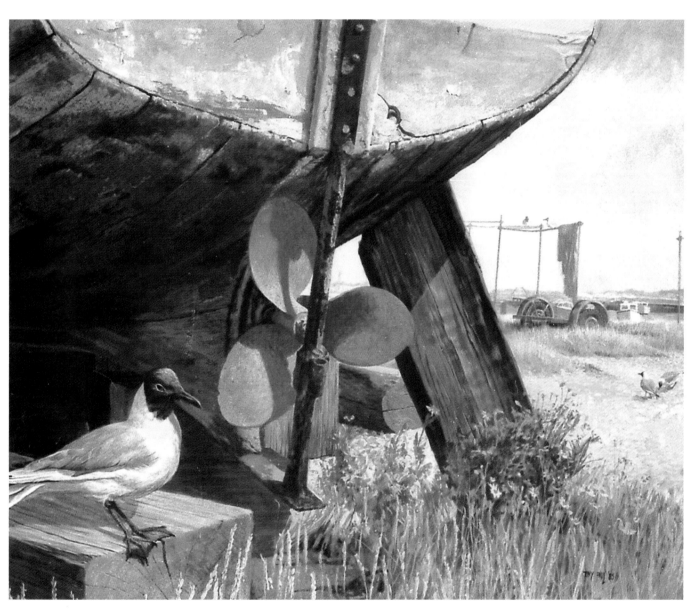

ABOVE Retired from the Sea; Tony Paul
Egg *tempera, 450 x 560 mm (18 x 22 in)*

THE OPEN SEA

ABOVE All Set for Quebec, Tony Paul
Oil on canvas, 508 x 762 mm (20 x 30 in)

When visiting a good exhibition of marine art you will find hundreds of paintings of seas, all different in technique and all saying something individual about their character. The sea has so many moods, governed by wind, weather, season, direction of light and location, so the variables are innumerable. In any other than a calm sea the waves comprise big shapes, within which are smaller movements.

In my oil 'All Set for Quebec', the evening sun is setting and we are looking into the dwindling light. There is still a reflected bluish light in the shadows of the waves and the glossy texture of the undulating sea is captured by the highlights on the crests of the waves and the softer lights in the troughs. See how the wave shapes decrease in size and get closer together as they recede into the distance.

In the watercolour 'Following the Ferry Out', the rhythmic swell has been shattered by the passage of the ferry with its entourage of small boats. I have used white gouache to help with the foaming of the wakes. The texture of the water was achieved by laying a light blue/green wash and overlaying this with broken and dry brush secondary washes. Again, note how I have created a feeling of distance by reducing the contrast within elements as they recede – see how strong the definition is of the foreground boat, as compared to the ferry.

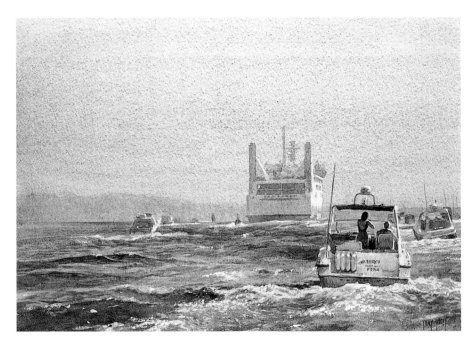

ABOVE Following the Ferry Out, Tony Paul
Watercolour, 305 x 400 mm (12 x 15½ in)

IN HARBOUR

In the relative shelter of a harbour the water surface is calmer than the open sea. The wave forms are smaller and often less ragged. In my water-colour 'Grey Day, Portsmouth', the sea is slight with fine repetitive waves in the foreground. The water's texture varies – the sea to the right of the tug is lighter, reflecting the sky, while to its left the surface has been ruffled into a darker tone by the wind. Again, diminishing scale and softening help with the sense of distance. The texture of the water was achieved by using a basic wash, slightly darker than that of the sky, overlaid by broken washes and a final layer of small brushwork that defined the ripples. I lifted out the overwash to create the light area of the tug boat's wake.

ABOVE Grey Day, Portsmouth; Tony Paul
Watercolour, 380 x 560 mm (15 x 22 in)

In the acrylic 'Dinghies', the ripples are gentler, rounded forms. The sea is darker than the sky and deepens in tone the closer it gets to us. The sun reflects brightly and irregularly. The water is represented by a blue that gradates to a very pale colour as it recedes to the land beyond. This was overlaid with greyish shadow tones applied in a broken and irregular way with a flat synthetic brush. Highlights were added, becoming smaller and closer together into the distance. An effect of light shining through the coloured sails of the dinghies was achieved by using bright, opaque colours.

RIGHT Dinghies; Tony Paul
Acrylic, 217 x 190 mm (8½ x 7½ in)

THE SEA SHORE

The acrylic of 'Bait Diggers, Poole Harbour' was begun by overpainting the lower part of the painting with a mirror reflection of the sky, made slightly darker. Over this I painted the distant land forms and, working from background to foreground, the distant boats, mudflats and figures.

As I painted the foreground, I changed to larger brushes so that the scale of the paint marks became larger, thus reinforcing the impression of distance. The piled sand created by the diggers has a darker shadowed side, so that it isn't confused with the gentler undulations of the sand. The finishing touch was to put some glisters of light at the edges of the sandbanks.

RIGHT *Bait Diggers, Poole Harbour*; Tony Paul
Acrylic, 300 x 400 mm (12 x 16 in)

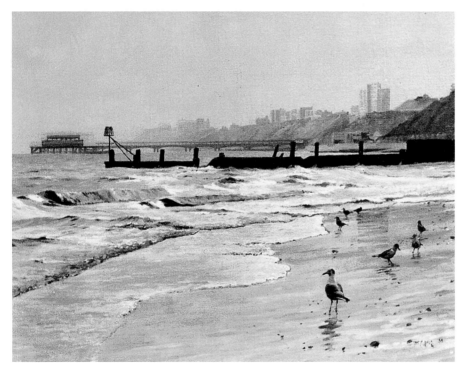

ABOVE *After the Holiday-makers Have Gone*; Tony Paul
Oil, 406 x 508 mm (14 x 20 in)

With 'After the Holiday-makers Have Gone', the procedures are the same. As they come forward the textures representing the waves become larger and more definite. See how much paler the pier is than the breakwater and how the cliffs soften into the background. The light and colour of the sky is reflected off the sea and only where the waves roll over, with their leading edges at a different angle, does the colour change to the complementary blue. This informs the viewer that the tumbling waves are at a different angle. Because the water is so disturbed and foamed at the shoreline it cannot form any reflections. It is only where the water is draining off the smooth sand that there are reflections of the tower block on the cliffs and the seagulls, but these are fractured and distorted by the undulations of the sand.

BEACH SCENES

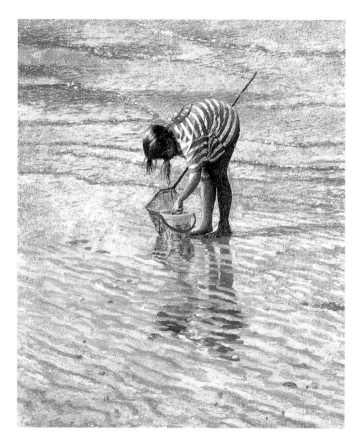

Children playing in the sand are eternal subjects for the painter. In the egg tempera 'The Yellow Bucket' the inspiration was the fine rippling on the beach contrasting with the broken reflection of the girl. See how the temperature of the colour, as much as the tone, changes where the back of her T-shirt turns into the side, a light from the water reflecting the sky's colour up into the shadows. There isn't much change in tone between the sunlit sand and the water either, the definition being made by the slightly darker shadow sides of the ripples. I made sure that these were consistent with the fall of light. It is important to paint what we see, not what we know. Like the front of her arm, we know her face is a soft pink, but look how dark it appears, even with light being reflected back, yet it looks right.

LEFT The Yellow Bucket, Tony Paul
Egg tempera, 300 x 200 mm (12 x 8 in)

Soft, dry sand is shown in the oil 'The Red Bucket'. In the extreme foreground the sand is the driest, forming shallow, somewhat rounded depressions. Down by the blue and pink windbreak the depressions are more marked. The slightly damp sand here is stickier, holding the shapes of the feet that have disturbed it. As the sand nears the water's edge it becomes damper still, smoother and more compacted, and will resist being displaced. A base colour for the sand was applied with darker shadows and highlights modelling its texture.

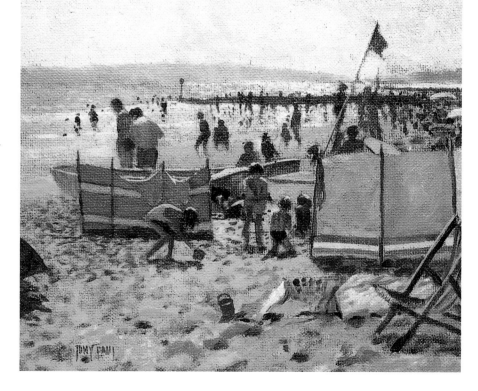

RIGHT The Red Bucket, Tony Paul
Oil, 250 x 300 mm (10 x 12 in)

BOATS

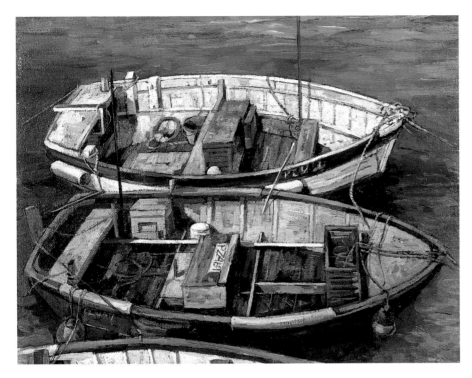

In her oil painting 'Rest Day, Newlyn', Sonia Robinson has shown some working boats. No gleam of chrome or sleek reflection from pristine fibreglass here, these boats have had a hard time.

I love the broken colours and textures, painted almost in dry brush, that create the workaday wear on the boats. If we look at the far boat, there appears to be considerable wear on the blue paintwork. It suggests the gloss coat has been partially rubbed away to reveal the paler undercoat and even the wood that underlies it. To get the crumbly look for the 'white' paint-work I would imagine that Sonia has applied dense paint sparingly over a darker underlayer and where the stroke breaks, little bits of dark are left to show through.

ABOVE Rest Day, Newlyn; Sonia Robinson
Oil, 406 x 508 mm (16 x 20 in)

The boats in my painting 'Barges on the Seine' have the same 'workaday' look as those in Sonia's painting. The steel barges line the rain-washed quay near the Pont des Arts in Paris. They are painted with my usual tempera technique – using small touches of different coloured but similarly toned paint.

As with any marine subject the water in which the vessels sit has to look right. Using careful observation I tried hard to give the water a sense of reality, particularly with regard to the reflections, using lights and darks to model the forms of the wavelets.

ABOVE Barges on the Seine; Tony Paul
Egg tempera, 508 x 660 mm (20 x 26 in)

MARINE PARAPHERNALIA

A characteristic of many of New England's quaysides is the buildings adorned with multi-coloured marker buoys. This one, a lobster shack at Cape Neddick in Maine, caught my eye. I liked the weathered textures and varied shapes of the buoys in contrast to the brownish timber boathouse and pier.

The sky and background were washed in with soft colours to push them to the other side of the inlet. Dry brush was used in the water and the shack washed in with a pale greyish brown. I left the marker buoys as white paper. The texture of the planking was applied with a fine brush, varying the brown from greenish to reddish. Over this I made random marks in diluted grey to indicate ageing, giving the wood a distressed look. The marker buoys were painted in with broken colour to describe their battered character. I was careful to give them a look of solidity and the shadows they cast helps with this. Transparent overlays of colour were added to 'dirty them up' a little.

RIGHT Lobster Shack, Cape Neddick, Maine; Tony Paul
Watercolour, 355 x 254 mm (14 x 10 in)

LEFT Dunlin and Lobster Pot; Tony Paul
Acrylic, 228 x 305 mm (9 x 12 in)

The discarded lobster pot sitting amongst wiry beach grass offered an exercise in texture that I couldn't resist. Layers of sponging, dry brush work and much overlaying of paint was necessary to build up the texture of the grasses and sandy beach. I used my 'ruined brushes' to work into the sand to suggest the crumbly grains and small stones. Dry brush applied with a 'ruined brush' was used to create the wood grain on the lumps of timber, the split hairs giving different thicknesses of line.

A dark underpainting was scrubbed thinly into the area where the grass was to be placed. Using a well pointed round synthetic brush I painted tangled grass shapes over this, then knocked them back with a thin, translucent darkish colour glaze. In seconds this was dry and I overlaid it with more grass, then partially knocked this back, continuing in this manner until I had achieved the depth of grass I was seeking.

The textures of the rough, worn polypropylene rope bound around the metal frame of the pot were achieved with a pointed brush, being sure to make the differences between light and shade evident. I added the Dunlin bird for extra interest.

ROCKS

The texture of large rocks has been beautifully described by Ronald Jesty in 'Portland Bill, Looking Eastward'. See how strong tonal differences, broken overlaid washes and speckly marks imply the weight, scale and texture of the strewn boulders. Without the figures we probably wouldn't realise just how massive some of these rocks actually are. I like the way that Ron has used tonal counterpoint – light against dark and dark against light. With the left hand figure he has used it twice – the figure reads clearly against the mid tone of the obelisk which in turn reads clearly against the sky.

ABOVE Portland Bill Looking Eastward; Ronald Jesty
Watercolour, 203 x 297 mm (8 x 11 in)

The thing that appealed to Richard Caplin about the subject 'Lichtenstein Gorge, Austria' was the way that the water circling around the boulders etched their shapes, eating away at their surface to reveal the beautiful mottled contours of varied colours: blues, pinks, reds and dark amber. Note how Richard has used different textures to represent rock and water. The water is rough and painted using marks that are loosely rounded, while the rocks are more tightly and formally painted implying their solidity. He looked hard at the rocks and noted how the wet planes and facets within them take and reflect the light, creating

ABOVE Lichtenstein Gorge, Austria; Richard Chaplin
Mixed media, 740 x 970 mm (29 x 38 in)

a matrix of colour and mainly rectangular forms. The painting was completed using water-soluble pencils, watercolours, gouache and acrylic paints.

MARINE SUBJECT IN WATERCOLOUR

Fishermen using low tide as a convenient time to service their boats is a common sight at Lyme Regis in Dorset. I felt that the subject would be ideal for a watercolour study.

Stage 1

After drawing the boat carefully – boats are difficult subjects and demand careful observation – the first washes were applied to the sky, distant land and sea. I kept these very pale to give an impression of aerial perspective. Next I applied tonal washes to set the forms in place. I used a mix of ultramarine and Indian red to create a dullish purple-grey for the elements in the boat and a warmer mix of vermilion hue and ultramarine for the harbour wall. The wall texture was created by applying the paint with a lightly loaded brush in a random way, and when it was dry I went over the lower parts with the boat mix to give the impression of stone and staining.

Stage 2

I moved on to the boat. Having established the basic tones I could now go for colour. To give the feeling of a real working boat I used a very lightly loaded brush on the hull, applying the paint in small dabs and allowing them to break into dry brush effects. For the roof and gantry I first applied a pink wash and as soon as this was dry added a denser red to model the detail. The floats and nets in the back of the boat were suggested and the cabin windows darkened. The flat sand was washed over with a warm beige and reddish colour dropped wet-on-wet into the sand by the boat's bow. The lower hull colours were used to create the boat's shadow on the damp sand and the pink reflection of the buoy added. Finally, the detail of the boat's number and the boom on the gantry and its associated rigging were added with a small brush.

Stage 3

To make the wall a little firmer I used a dilute mix of ultramarine and Indian red, applying it in a hit and miss fashion to strengthen the texture of the stone. I used a little raw sienna to make the edge stones prominent and darkened in the cannon. The figures were refined carefully but simply and darker reflections added in the foreground. Final details such as the chains and ropes embedded in the sand and the ripples of the water by the wall completed the painting.

BELOW Low Tide, Lyme Regis; Tony Paul
Watercolour, 254 x 330 mm (10 x 13 in)

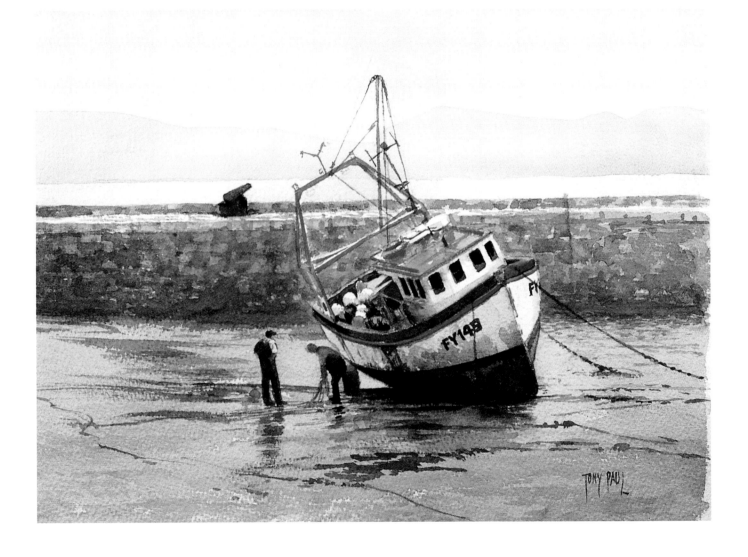

MARINE SUBJECT IN PASTELS

I took the photo on which this painting was based at Poole Harbour. The day was coming to a close and two of my daughters wanted a 'last paddle' before we went home. I decided that I would change the painting to a portrait shape and leave out the large foreground boat as it drew the eye too much to the side of the painting. I liked the effect of the sun on the wet sand and how this texture differed from that of the water.

Stage 1
Using the smoother side of a buff-grey pastel paper I started roughing in the elements of the painting. I did a fair bit of work on the sky achieving its broken texture by using the sides of the pastels, breaking into and overlaying colour over colour. I then used broken colour to block in the townscape in the background and began suggesting the water with short strokes of pastel drawn with the square edge of the stick. I thought that the boat in the photo looked a little too basic and just sat within the water. Making it into a cruiser gave the hull more height and a mast that visually linked it with the background and other masts. The figures were roughed in as silhouettes.

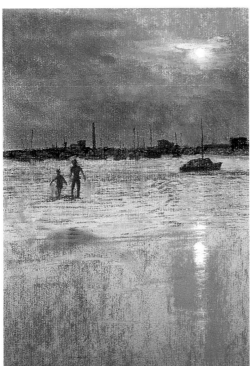

Stage 2
The sea was completed using a mix of blue, pink, green, orange and yellow pastels applied in small dashes. These blend to create the impression of sparkling water. The texture of the smooth sand needed a different treatment, so I reverted to using the pastel on its side making broader movements. The puddles on the left are taking shape and I painted the wavelets carefully and finished this stage by softening the hard silhouettes of the figures adding an aura of light on their heads and shoulders.

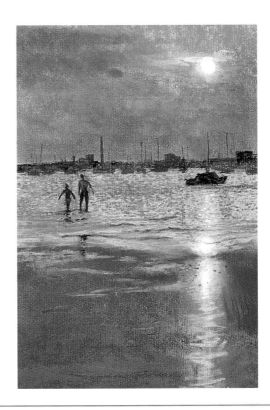

Stage 3

I worked on the wet sand bringing it down to the bottom of the painting. See how much sharper the reflection of the sun is in the wet sand against that in the water. The stones and seaweed were added to punctuate the wet sand. I was careful to make sure that these had hints of shadows. I did this by slightly smudging the pastel downwards with a tip of the finger. Finally, I added little refining touches here and there to complete the painting.

BELOW The Last Paddle of the Day; Tony Paul
Pastel, 407 x 305 mm (16 x 12 in)

PART SIX
TEXTURES IN BUILDINGS

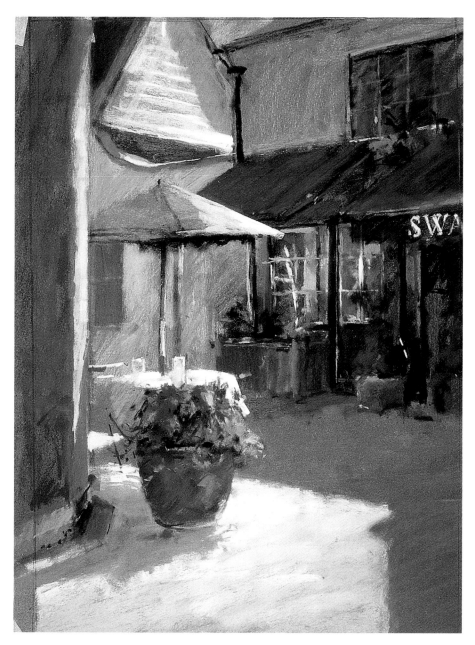

ABOVE Al Fresco; John Patchett
Pastel, 495 x 343 mm (19½ x 13½ in)

ROOFS

The texture of a roof depends largely on its age and type. Small clay tiles as in the pastel 'Autumn over the Roofs' over time attract lichens and moss which will modify its colour and texture. At one time all of the roof would have been as orange coloured as the ridge tiles, but now is a multitude of colours. The lines indicating the rows of tiles are softened by the growths of moss and lichens and there are occasional dashes of orange where a newer tile has been replaced for a broken one.

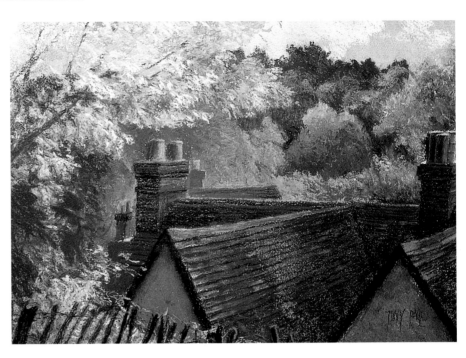

RIGHT Autumn over the Roofs; Tony Paul
Pastel, 330 x 483 mm (13 x 19 in)

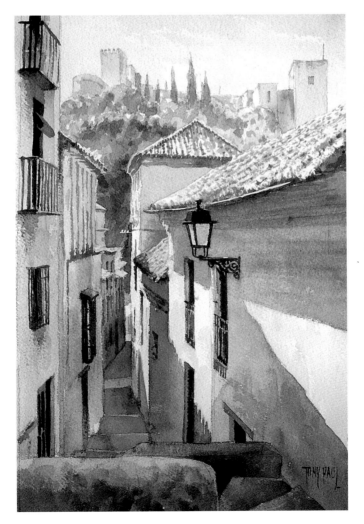

In 'Below the Alhambra, Granada', the roofs are again of clay tiles, but of the curved Mediterranean type. The textures can vary according to their age and condition. The roofs in the painting are old, undulating and irregular and at a distance appear vertically ribbed. Seen from the side it is apparent how uneven and hotch-potch the tiles are. Unlike the first illustration these tiles are less subject to moss and lichens. A further example of this kind of roof can be seen on page 92.

LEFT Below the Alhambra, Granada;
Tony Paul
Watercolour, 305 x 228 mm (12 x 9 in)

WALL TEXTURES

In my watercolour 'Preparing Gondolas, Venice', there are two basic wall textures – rendered and brick. The Venetian rendering is faded, patched and stained, offering the watercolourist ideal opportunities for wet-on-wet work.

Once the initial washes are dry, streaks of staining can be added and broken textures laid over the top to imply damaged render or exposed bricks. Most of the brickwork is old and the bricks themselves are greatly worn, giving an irregular look. The brickwork of 'A Gateway, Sissinghurst Gardens' is old, with yellowish and grey lichens but is in a good state of repair. The wall was masked off and sponged in various coloured layers. The dark lines that show the under edge of the bricks were drawn first, the lighter line, implying the mortar and sunlit tops of the bricks was added after. Similar treatment was given to the brick paving of the path. I went back over the bricks with a 'ruined brush' and added little blotches and darker touches to give more variety to the textures.

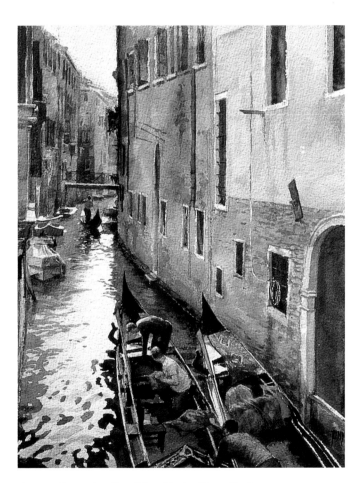

ABOVE Preparing Gondolas, Venice; Tony Paul
Watercolour, 381 x 305 mm (15 x 12 in)

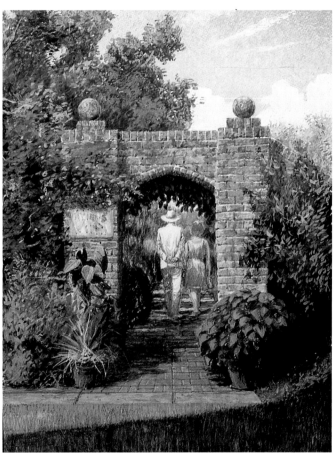

ABOVE A Gateway, Sissinghurst Gardens; Tony Paul
Egg tempera, 240 x 305 mm (9 x 12 in)

WINDOWS

The difficulty with painting windows is similar to that of glass in still life – their substance is usually transparent – so how do you paint transparent? You can't. But fortunately windows and glass are also reflective and can slightly alter the colours or tones of what lies behind. We can use this to create the impression of a glazed window. If you look at my watercolour 'Watching the World Go By' you will see how I have dealt with it. The top window has a degree of light reflected off the glass, making it greyish. The glass in the open window immediately below is indicated by adding a very pale wash within the frame. Because the pipe on the wall can be seen within the window, it appears transparent.

The main window is open. If we compare the tones of the brown and black areas behind the figure, and those of the window panes above him, you will see that the latter are lighter, implying that there is something between the outside and inside of the building.

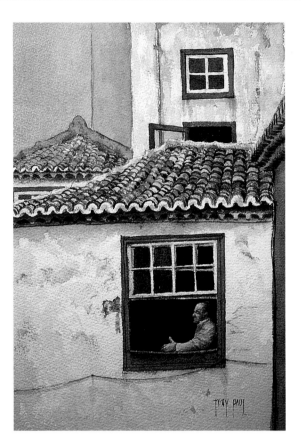

RIGHT *Watching The World Go By*, Tony Paul
Watercolour, 330 x 228 mm (13 x 9 in)

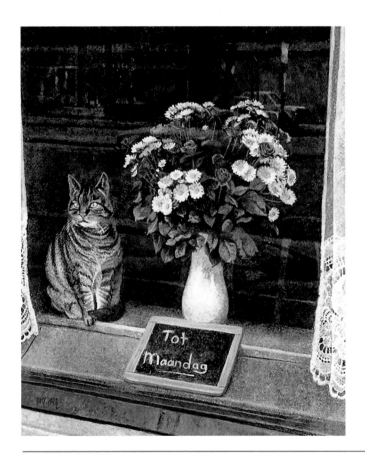
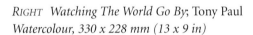

In 'Tot Maandag' the cat sits in the cafe window by the flowers and net curtains. The interior of the cafe is dark with just vague indications of chairs or table legs. Because of the dark, the window acts as a dull mirror and in it we can see the pavement, the road with three cars, the shops on the opposite side of the road, some trees and vegetation and a traffic sign. This is a difficult subject as the reflections are only evident against the dark interior, but disappear against anything light.

LEFT *Tot Maandag*, Tony Paul
Egg tempera, 356 x 293 mm (14 x 11½ in)

OUTHOUSES

Bill was one of those people who collected things others discarded, on the assumption that at some point they would come in useful. So much so that he had to erect a building to accommodate it all. The shed itself was built from timber, corrugated iron and other materials that he'd acquired. Its construction spurred him to even greater efforts and before long it was overflowing with items like the cone, barrel and scuttle left outside.

My watercolour shows his shed a decade after it was 'built'. By this time the frame was sagging and rotten in parts, the aged corrugated iron rusted badly and was all patches, its sagging edge propped up by a tree branch.

The depiction of the decayed iron and wood had to be treated carefully. The missing window panes were a soft black made from a mix of ultramarine and burnt umber. The rust was a mix of Indian red and burnt sienna – the very old sheet behind the coal scuttle and cone was a mix of Indian red and ultramarine. I lifted out the black to create the board in the bottom left window and painted the dirty and broken windows with a diluted grey applied dryly to appear dirty. The board was continued by making the mix darker in the upper part. The colours of the stained and faded woodwork were based on mixes of burnt umber, Indian red and ultramarine.

ABOVE *Bill's Shed*; Tony Paul
Watercolour, 297 x 210 mm (11³/₄ x 8¹/₄ in)

STONE

'On the Window Sill' is a close-up of a window of a stone barn in France. The stone is old and crumbling, its granular texture achieved by sponged layers of varying pale colours with bluer, darker shadow areas. Over this I built up grainy opaque lights applied with a small brush. The change between the light tone of the ledge and the darker tone of the vertical wall reveals the edge of the stone sill. I liked the contrasts between the textures of the reflective brown glass, the cracked wood and the crumbly stone.

LEFT On the Window Sill; Tony Paul
Egg tempera, 297 x 204 mm (11 x 8 in)

'A Corner of Santa Maria della Salute, Venice' was a sketchbook study carried out in pen and wash. The stone, brilliant white in parts, was darkened and stained in others, but what I liked about the subject was the colours of the shadow areas – a cool, soft mauve in the clear Venetian light.

With limited time before the light changed I worked on a corner of one of the eight faces of the building. After drawing the building with a waterproof pen, I put in the shadows carefully but quickly in a mix of manganese blue and permanent rose. When this was done the architecture looked pristine and new, which was far from the effect I was seeking. Looking at the staining I could see hints of burnt sienna, ultramarine and raw sienna and applied these colours in broken mixes over the first washes. The broken nature of these overlays helps to convey a sense of aged texture to the stonework.

RIGHT A Corner of Santa Maria della Salute, Venice; Tony Paul
Pen and wash, 255 x 178 mm (10 x 7 in)

TIMBER

ABOVE Chattel House, St Kitts; Tony Paul
Watercolour, 240 x 320 mm (9½ x 12½ in)

In all the Caribbean islands, chattel houses appear to be the people's main type of home. Typically they are single storey, built of timber and often painted in bright colours, roofed in corrugated iron and incorporating a veranda where the occupants can sit and watch the world go by. Most are set upon brick or stone piers with two or three steps up to the entrance door. Their condition can vary between pristine and virtually derelict.

The St Kitts chattel house illustrated in my watercolour is quite old and, as can be seen from the painting, has been extended at the rear. The old boards are weathered and stained near the ground. Initially the boards were given a pale underwash. The side on which the bike leans is taking the light and so is warmer in hue than the side with the open door, which is based on a dull purple made from Indian red and ultramarine.

The wood graining was applied with a smaller brush and often smudged with a finger, and the rusty iron roof was painted with Indian red, burnt sienna and ultramarine. The sheets that still retain their galvanized coating reflect the colour of the sky and were painted with manganese blue and a touch of Indian red. I added the umbrella to give a splash of colour.

When all the wood graining and roof textures were in place, I added the final details, indicating nail holes, the patterns on the blinds, the joints between the planks and gaps between the ridge strips and roof corrugations. The bike was painted carefully with a mix of burnt umber and ultramarine with highlights touched in with white gouache. The painting is a good exercise in the achieving of various textures.

DECAY

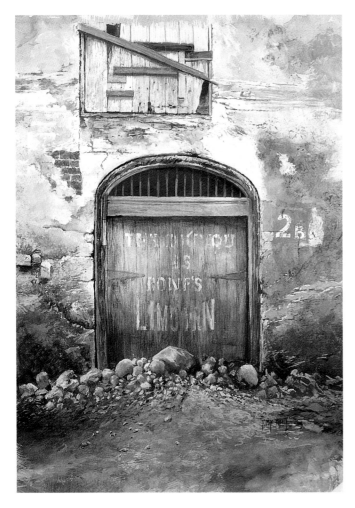

Because of its textural qualities, decay is always interesting to paint. In the gouache 'Derelict Building, Bridgetown, Barbados', I used a lot of the textural effects described in the earlier part of the book, including torn sponge work, general sponging, masking, spattering, glazing, scumbling, lifting off and using my 'ruined brush' as well as standard brushes. It is almost impossible (and unnecessary) to be utterly literal to the subject, so when overlaying the textures, I used the accidental edges and paint effects as a base on which to elaborate the cracks, lumps, tones and colours that were within the subject. These were then worked into and modified as necessary to achieve the required textures ensuring that the character of the building was accurately suggested.

LEFT Derelict Building, Bridgetown, Barbados; Tony Paul
Gouache, 367 x 279 mm (14¹/₂ x 11 in)

In 'Apple on a Fence', I was interested in comparing the firm fleshed apple and the raddled old fence and concrete fencepost. Again, multi-layered sponging was used for the concrete posts, while more linear work modelled the etched timber. Broken washes of various colours mottled the wood. As is usual with tempera work the painting was built in layers each working with the underlayers to create the textures required. The apple was painted largely with thin, transparent glazes over the white gesso, the yellows, pinks and reds overlapping to make the blotched skin. 'Happy accidents' in the sponged effects were elaborated on to make the cracks and holes in the concrete pillar.

RIGHT Apple on a Fence; Tony Paul
Egg tempera, 170 x 140 mm (7 x 6 in)

FARM BUILDINGS IN WATERCOLOUR

I found this crumbling range of buildings at a farm in the village of Bagneux, in the Loire region of France. I couldn't resist the textures and felt that it would be an excellent subject for a watercolour.

Stage 1

After completing the drawing, I applied touches of masking fluid to preserve some highlights. The sky was blocked in first and while still wet the dull purple of the distant trees was added. This helped the edges to diffuse and create a softer appearance.

Using wet-on-wet techniques, I painted the pale walls of the buildings allowing the colours to blend smoothly. The colour was greyer on the right near the ground and bluish on the door. I blocked in the dark interior, then wetted the lower part of the door reveal and flooded in the shadow colour to indicate the staining.

Then I scrubbed in the ground colour, allowing the wash to break here and there, and finally applied shadow colour where the foliage was to go.

Stage 2

Working from the background forward, I added more definition to the distant trees by lifting off a little colour to create edges, and adding stronger tones to imply layers of trees. The tree above the far roof helped to define its edge and I 'dirtied up' the walls of the far building with a broken purply mix. The lighter colour of the vegetation and the discarded oil tank were worked in, and the detail of the arched doorway resolved. I added a wash to the wall of the main building and then used broken washes of various colours for the ground. Finally I returned to the vegetation adding broken touches of darker green to imply more shadowed areas and added the detail of longer grass in the right foreground.

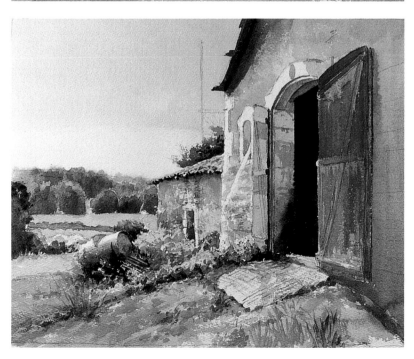

Stage 3

The majority of the work was in place so I felt that it was safe to remove the masking fluid. This revealed the lights within the foliage and on the ledges of the barn doors.

I turned my attention to the doors, drawing in the planking with a fine brush. With a mix of broken washes and finer detail I worked into the barn wall to age it and darkened its shadow on the bottom right. I felt that there still wasn't the effect of reflected light in the stone of the doorway so added more colour, which seemed to do the trick. I used the same mix in the small window to the left of the doors.

I mixed up some dark colour and refined the roofline, put in the planks by the window, painted the disc above the arched doorway and added the bracket and mast on the edge of the wall. Last touches were to roam all over the picture refining small details.

BELOW *Farm Buildings, Bagneux, France*; Tony Paul
Watercolour, 305 x 400 mm (12 x 15¾ in)

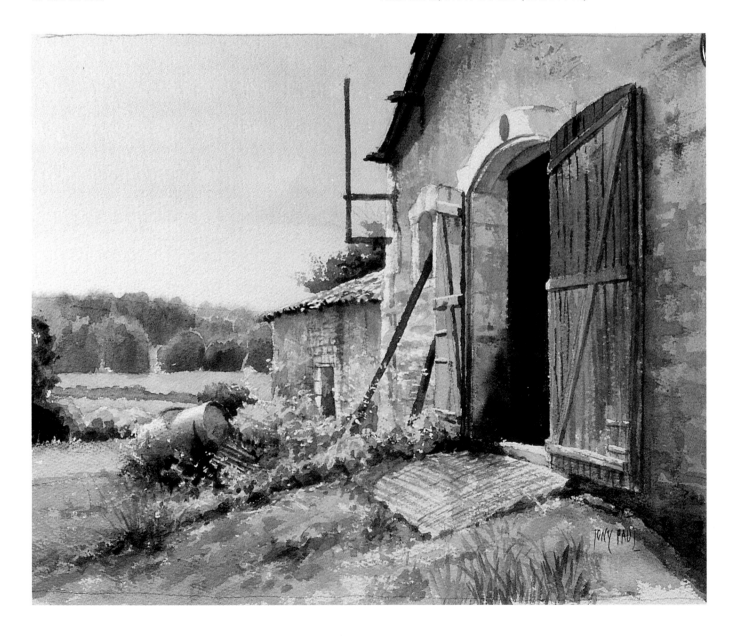

BUILDINGS IN OILS

The main thing I liked about this subject was the strong, warm light on the upper storeys of the buildings on the left of the painting. I was interested in the contrast between this light and the more subdued tones and colours of the areas in the shadows. At the time when the photograph was taken, the bronze lions at each corner of the monument were being restored and were covered by a plastic sheeted screen. Obviously I didn't want this to feature in the painting, so upon my next visit to London I took another photograph with the restored lions in place.

Stage 1

Using a buff tinted canvas I began by drawing the image with diluted oil paint applied with a small brush. Once the drawing was established, I blocked in the main elements using my mix of cobalt green dark and Indian red, lightened where necessary with flake white. This started the 'fat over lean' principle well, as all three colours are fast drying and low in oil. Having established the basic darks and lights of the subject, I added colour in the form of Naples yellow, cadmium yellow deep and coeruleum blue.

Stage 2

Having allowed the underlayer to dry, I began work on the second stage by putting in the sky. Its added warmth made the colours of the left hand building look right but I didn't feel that the upper storeys glowed enough. Working on the principle that to make something appear lighter its surroundings need to be darker, I darkened the tones of the lower parts of the buildings and the rest of the painting. The sunlit trees in the centre were developed a little more and Big Ben's shape and colours refined – I was careful not to make the tonal contrast too great, as I wanted it to look a fair distance away from the other buildings. Next I put in some careful work on the right hand buildings suggesting the detail of their stonework. I reinforced some of the lights using the opacity of titanium white and some lemon yellow.

Stage 3

I then began work on the right side of the painting. Beginning with the base of Nelson's column, I refined the drawing of the plinth, clarified the buildings behind it and resolved the lamp, keeping the brushwork loose and lively. Again I darkened the ground and restated the balustrade and the pattern on the pavement. My attention then turned to the lions, which were given stronger darks to make them come forward more.

To finish off, I suggested people, cars and lights with touches of colour here and there. This is very much a sketch, but I feel I have caught something of the atmosphere of the subject using the characteristic texture of oil paint.

BELOW *Big Ben, Evening Light*, Tony Paul
Oil, 457 x 355 mm (18 x 14 in)

PART SEVEN
ANIMAL TEXTURES

ABOVE Winter Robin, Tony Paul
Watercolour, 240 x 170 mm (9 x 7 in)

FUR AND FEATHERS

As we have found, most surface textures vary and this is very true of feathers and the fur of animals. Each species will have its own characteristic texture and, even within a species there will be differences: could you use the same textures for a Dachshund and an Old English Sheepdog?

The illustrations below by Daphne Ellman offer an excellent step-by-step approach to the representation of fur and feathers, and can be used in both opaque and watercolour techniques. The marks could be modified to give both smoother and coarser effects.

FUR

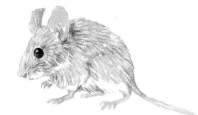
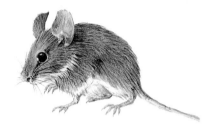

Stage 1
After drawing, the first step was to begin to model the texture of the darker areas of the fur with small brushstrokes aligned to indicate the 'nap' of the fur. When dry, this was then overlaid with a thin, transparent wash to give the colour of the fur.

Stage 2
Opaque white was used to work over the fur, bringing out the highlights and helping to create the form of the animal by making the marks follow its contours.

Stage 3
Thin coloured glazes were applied and modified by further detailed texturing as required to achieve the quality of the fur. Dark accents can be applied to give the illusion of the hair parting, as below the shoulder.

FEATHERS
The same principles apply to the depiction of feathers. With larger birds such as the Tawny Owl on page 104, the detail of the filaments of the feathers will be too fine to register unless parted, but with small birds such as the Coal Tit below this fine detail should be described.

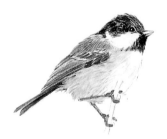
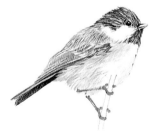

Stage 1
Here, the textures are more drawn than painted. The texture of the head feathers differs from that of the mantle and chest feathers, and the wing coverts and flight feathers have a stiff appearance. The darker elements of the plumage are textured in following the forms of the bird and transparent, appropriately-coloured washes are laid over the top.

Stage 2
White, applied with a fine brush is overlaid to add light modelling. Note how the mantle feathers have been softened and how fine cross hatching has indicated the filaments on the flight feathers, with white lines defining their edges.

Stage 3
Appropriate transparent colours are washed over the subject. These will soften the lines and, when dry, further definition can be added to give the bird a feeling of reality.

FUR TEXTURES

The fur on Khan's head varies considerably in length. On the forehead, cheeks and muzzle the hair is quite short, while on the neck it is thicker and longer. The white paper was left for the highlights, so I painted the shapes around them to create its texture. Then directional lines were drawn over the head in the appropriate colour to create the linear texture of the fur. The lines on the head are short and fine, following the shape of the head, while those around the neck are sweeping and softer. Washes were applied over the modelling to reduce its rather harsh character and help give a sense of solid form – look how the left side of Khan's head is darker than the right, and the fur under the chin darker still.

LEFT *Khan*, Tony Paul
Watercolour, 355 x 250 mm (14 x 10 in)

The fur of the squirrel is finer and close packed, separating at crease points to show 'cracks'. Its surface is dull without any sheen. The underpainting is dark and the texture painted over this using a blend of lighter blue grey, brown and purple strokes applied with a fine brush. In describing the fur's texture I took great care not to forget to make the animal look solid and 'real'.

It is interesting to compare the different textures in the painting. The bark was more broadly treated, while the thatched bird table is painted in some detail. The translucent quality of acrylic paint was used to portray the overlapping leaves in the background.

RIGHT *The Thief,* Tony Paul
Acrylic, 217 x 250 mm (9 x 10 in)

FEATHERS

Many of the feathers of the tawny owl of Daphne Ellman's 'Evening Light' have been painted individually, simply because they are not as clumped into a mass as are those of the collared doves below. The technique involved in the painting of this picture is as Daphne describes on page 102. She has taken great care to differentiate between the kinds of feathers on the bird. If you look at the face the character of the feathers is more hair like, while those of the mantle and wing coverts are softer and fluffier in appearance. The flight feathers of the wing and tail are firm and strong, the filaments are parted here and there to give them added form and texture. The painting has been completed using similar detail throughout. Note how, in the background leaves and haws, they are slightly softer, giving a sense of aerial perspective and, consequently, distance.

LEFT Evening Light; Daphne Ellman
Acrylic, 508 x 406 mm (20 x 16 in)

In this watercolour, the collared doves were painted from light to dark. I first masked out the leaves, tree and birds, and after wetting the paper all over dropped the pre-prepared greens and browns on to it allowing the colours to fuse and spread to give an out of focus effect. When this was dry, I painted in the paler colours of the doves and then worked my way through to the darker colours, being concerned with making the birds look solid, yet keeping a light touch. Using a small brush, the detail of the feathers was added. Keeping light edges, the leaves were painted carefully and the tree trunk mapped in using wet-on-wet technique. Using irregularities in the wash I created the smaller details, lifting off and adding colour where necessary.

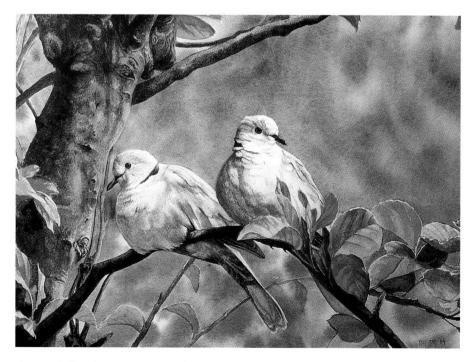

ABOVE Collared Doves; Tony Paul
Watercolour, 381 x 254 mm (15 x 10 in)

MAMMALS

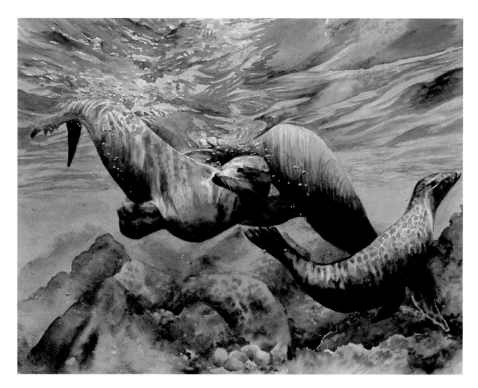

The sea lions in Caroline Bletsis's painting 'Underwater Ballet' show the graceful and lithe animals in their natural element. The close fur is smooth and at the distance shown will appear as skin. The texture of the water's disturbed surface as seen from below, has been well observed and skilfully painted and the dappling of light represented in small wet-on-wet washes overlaid over one another. The rocks on the seabed have the kind of diffused half focused look that you get with underwater subjects and, like the sea lions they are dappled with the light from above.

LEFT Underwater Ballet; Caroline Bletsis Watercolour, 305 x 406 mm (12 x 16 in)

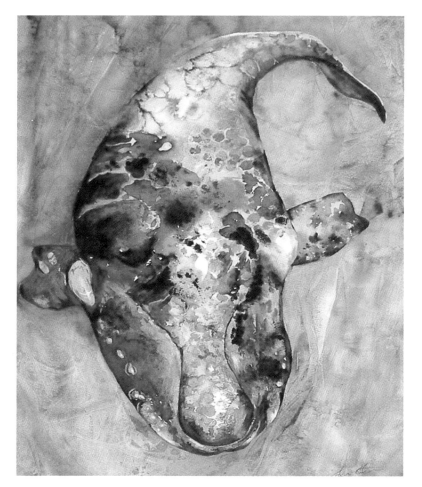

Caroline's 'Blue Whale' is an exercise in the use of texture. She has used the salt technique (see page 32) on the back and head of the animal, while plastic wrap (clingfilm) techniques (see page 34) allied with big wet-on-wet washes have been used in the water areas. The textures on the head are slightly impasted and overlaid, while the body has less overworking, you can see a honeycomb effect created by applying paint to bubblewrap and printing this on to the surface.

The effects could have appeared disjointed, but Caroline's skill in making them support, rather than dominate the subject, has helped to create a beautifully unified textural painting.

LEFT Blue Whale; Caroline Bletsis Watercolour, 457 x 355 mm (18 x 14 in)

FARMYARD

In her delightfully stylized painting 'The Cow Dealers', Lisa Graa Jensen has used several different techniques to create the various textures. Her method is consistent; using a rough surfaced watercolour paper she works simple underlayer colours in first, either brushing them in or rubbing them in with her fingers, then overlaying to build up the required colours and textures. It can take several layers of work before she is happy with the finish. Lisa uses small synthetic brushes – sizes 0 and 1 – using stippling and dry brush effects, blending white gouache in with the acrylic inks to achieve opacity. The final layer brings the work into sharp focus, being based on fine stippling and line work.

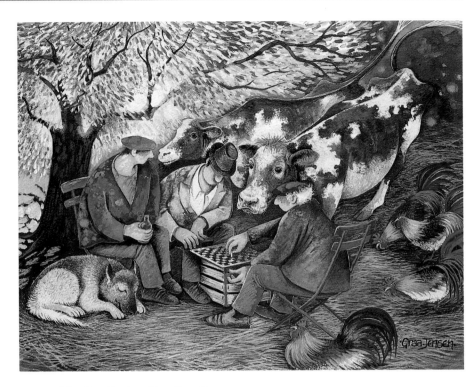

ABOVE *The Cow Dealers*; Lisa Graa Jensen
Acrylic ink/gouache, 254 x 356 mm (10 x 14 in)

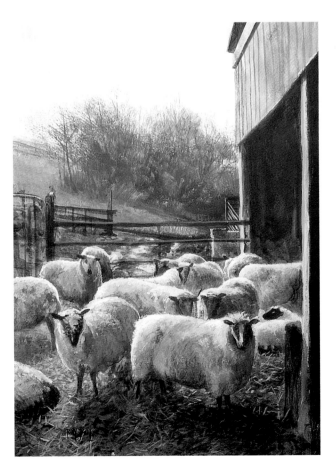

On a sheet of rough watercolour paper I worked from background to foreground for my painting of 'Sheep at Kingcombe'. The first stage was to thinly paint in the sky, scrubbing in the colour and, when dry, overlaying the greyish cloud. I roughly mapped in the green of the hill, overlaying this with a cooler and darker green then worked in the trees in a mix of green and purple, dry brushing out from the edge of the tree to imply fine twigs. I then 'roughed in' the barn, the browns of the ground and the sheep, allowing the brushstrokes of dense paint to break up into dry brush effects to give the impression of wool. I then went back over the painting and refined the many forms, detailing in the fences, the sheeps' faces and the straw strewn ground.

LEFT *Sheep at Kingcombe*; Tony Paul
Acrylic, 356 x 254 mm (14 x 10 in)

BIG CATS

The fairly large acrylic 'Cheetah' was painted on a medium grain canvas. An extensive underpainting was done to establish the main tones and forms, the land beyond the trees was left as underpainting and the small areas of green put in. I worked on the far cheetah, the dappled light modelling its head against the darker background. The foreground animal was worked in sharper focus, the spots of its fur being created with diffused lines that followed the direction of the fur's 'nap'. The strongly lit head was modelled carefully with a small brush and worked into reasonably fine detail.

I enjoyed the work on the dry grass as much as I did on the cheetah. Working light strokes with a small brush over the darker underpainting, I then glazed over them with a transparent half dark colour to push them back, repeating the process as many times as necessary to achieve the required density.

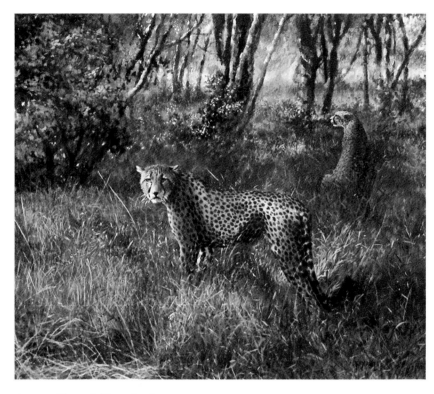

ABOVE Cheetah; Tony Paul
Acrylic, 610 x 760 mm (24 x 30 in)

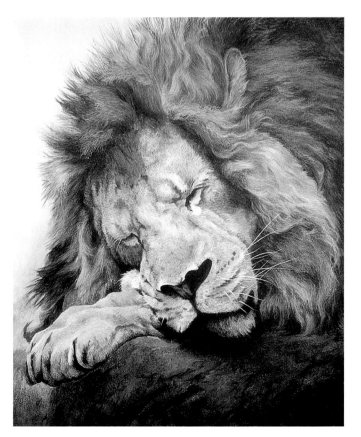

What I like about Lauren Hayes-Bissell's acrylic 'Shumba Lala' is the wonderful representation of the different qualities of hair texture on the sleeping lion. See in the mane the hair is wiry and thick, while on the face and paw it is much shorter and smoother. The detailing of the fur was applied over a looser underlayer that modelled the animal's form.

LEFT Shumba Lala; Lauren Hayes-Bissell
Acrylic, 508 x 406 mm (20 x 16 in)

ELEPHANTS

In these two oil paintings by David Kelly we can see different aspects of these wonderful beasts. In the first painting 'The Patriarch', the dusty elephant is confronting us whereas in the second it is relaxed, content in its ablutions. The paint was applied flatly for the sky but was scumbled roughly, dark over light in the foreground to create an impression of tangled dry grass. Sharp edged detail helps create the effects of strong light.

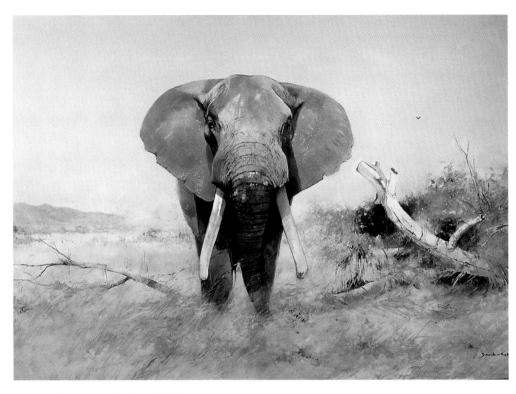

ABOVE The Patriarch; David Kelly
Oil, 508 x 726 mm (20 x 30 in)

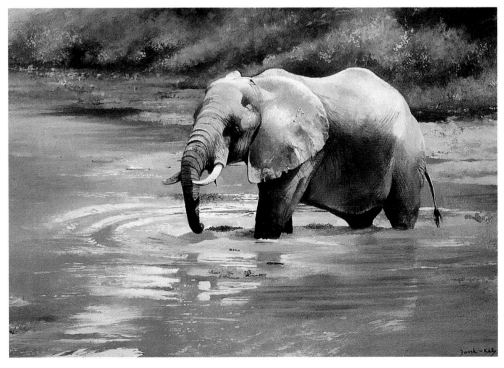

The elephant in 'At the Waterhole' is beautifully modelled. See how important it is to create a sense of solidity, the broadly painted elephant, water and background brought into focus with the sharply defined detail of the deep creases in the leathery skin.

ABOVE At the Waterhole; David Kelly
Oil, 406 x 686 mm (16 x 27 in)

GARDEN BIRDS IN WATERCOLOUR

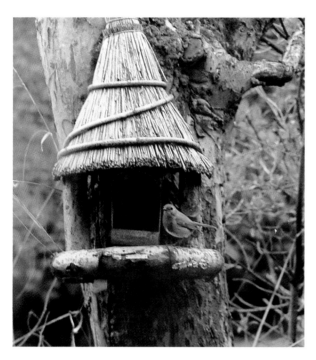

The amount of texture in the subject demanded a fairly detailed approach. I added two more birds – a great tit and a blue tit from other references.

Stage 1

After drawing the subject, I masked off the tangled grasses ready for large background washes to be applied. I first mixed up pools of quite dense colours based on phthalo green mixed with raw sienna, gamboge hue, burnt sienna and burnt umber. This gave me a range of tones of green that varied from light and bright to dull and dark. Applying plain water to the background areas, carefully avoiding the tree, I then dropped in the colour wet-on-wet, giving a diffused effect. This stage was completed by washing in the tones of the tree and bird table leaving the two birds as white paper.

Stage 2

After rubbing off the masking fluid I began to define the textures of the tree. Although I broadly referred to the photograph, I used edges and textures of the underpaint and built on these to give form to the tree. Here and there I darkened either the tree or the background to ensure that the tree read clearly. I washed over the thatch of the bird table, adding the blue tit and roughing in the colouring of all three birds. Having done this I went over the tree and, using a small brush put fine detail into the moss and the gnarling of the bark. Finally I roughed in the thatch details.

Stage 3

I found the bare white of the grasses distracting and so washed them over with various colours, mainly blends of Indian red, burnt sienna and raw sienna, relieved by greens made from ultramarine and raw sienna, and phthalo green and gamboge hue.

Before beginning work on the birds (I usually leave the most enjoyable part of the painting until last) I defined the roof of the bird table. See how important the change of tone is in showing how the thin wire binding has pulled in the straw just above the blue tit.

Working from top to bottom, I detailed in the birds. I was careful to ensure that they looked three dimensional. When I was happy that they looked solid enough, I refined their shapes and focused on the feather textures, detailing the modelling carefully. Finally I went over small areas of the painting touching in highlights with white gouache and dark accents.

BELOW Waiting Their Turn; Tony Paul
Watercolour, 406 x 305 mm (16 x 12 in)

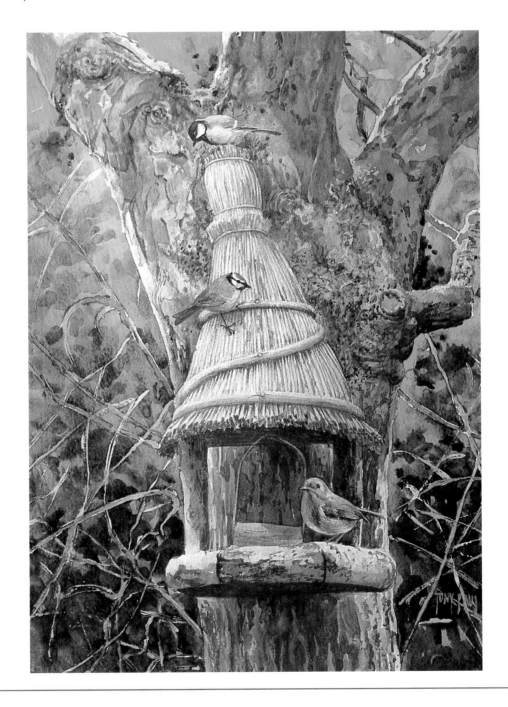

LION IN PASTEL

The photograph was taken by a friend on a safari. The quality isn't great but there was sufficient information to make a painting from it. With a subject such as this, information and a sense of tone are the important aspects. However, the photograph doesn't have to be razor sharp or professionally taken. It is far more important for it to 'say' something about the subject.

Stage 1

I chose a handmade tan pastel paper for this subject. The paper had a wonderfully 'nubbly' texture and I wanted this painting to have a looser quality with the texture of the pastel prominently featured.

As I often do, I began by creating a tonal underpainting, largely of greys, to establish a sense of form in the animal. The lighting is from behind the lion and its face is largely in shadow with the colours cool and neutral. The brown of the paper shows through in parts of the face and acts as a counterpoint to the cool violets and blues. Keeping the features soft, I worked on getting the fringe of light on the mane, its back and on the fringe of its ear. I put in some ochre to lighten the background and indicate the plains of grass.

Stage 2

I began by working into the tone with colour – warm colours into the mane and cool blues in the muzzle. As is usual with pastel, much of the colour is blended on the paper. I drew into the mane with colour – red, brown and ochre, trying to give the sensation of the coarse hair. I worked into the face strengthening the features and going for the look of concentration on its face. I deliberately avoided trying for any detail at this stage. Capturing a rugged quality was more important. I faded out the shoulders as I didn't want the 'decapitated' look that some wildlife portraits have.

Stage 3

I made sure that the lights were emphasized on the right side of the head and refined and brought more colour into the face, blending some of the mane colours into its cheek. The colours were applied in short strokes to imply the short facial hair in contrast to the longer, irregular strokes for the coarse, wiry hair of the mane and the stiff hair of its whiskers.

I revisited the eyes and developed them, making their intense gaze the focus of the study. Finally, the curtain of tall grasses was added to give a setting to the head.

BELOW *Biding His Time*, Tony Paul
Pastel, 280 x 381 mm (11 x 15 in)

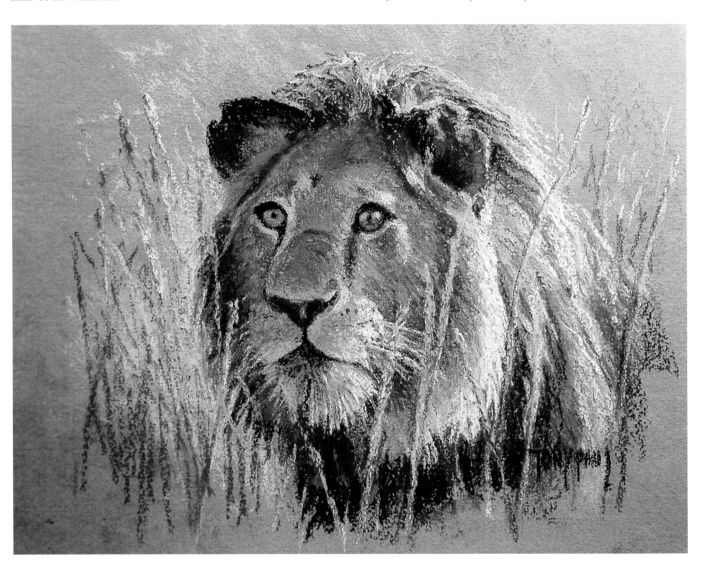

PART EIGHT
TEXTURES IN ABSTRACT ART

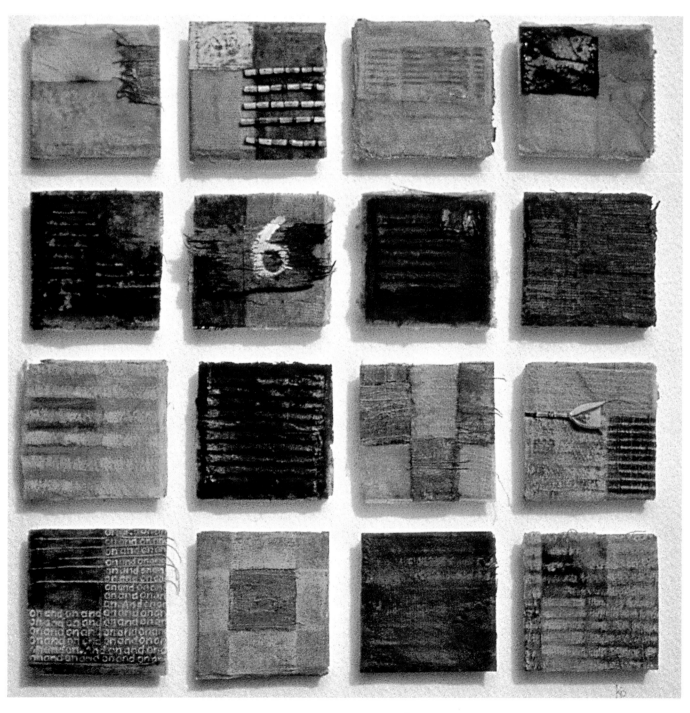

ABOVE No. 6; Kerry Paul
Mixed media, 305 x 305 mm (12 x 12 in)

SEMI-ABSTRACT

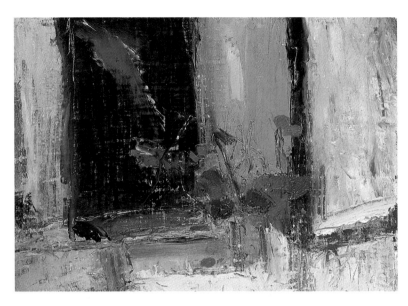

ABOVE Blue, Ochre and Red; Nick Tidnam
Oil, 280 x 305 mm (11 x 12 in)

While purely abstract work can have no direct reference to things seen, semi-abstract work is a bridge between the observed subject and imagination. In Nick Tidnam's 'Blue, Ochre and Red' the subject is based on a small floral still life. Painted in an expressionist technique, the subject is the vehicle through which Nick explores the textural delights of oil paint, applying a basic layer with a palette knife and overlaying this to build up impasto. Nick feels that the drawing stage is important, particularly as a means of investigating the subject prior to painting, but is also used throughout the painting process. See how defining lines have been carved into the wet paint with the point of a painting knife.

Geoffrey Robinson simplifies objects almost to symbols and changes viewpoints to create flat planes that work in an abstract way. Influenced by the work of Ben Nicholson, William Scott, Christopher Wood and Mary Fedden, his work is precise and carefully made. His use of textures is very subtle and quietly controlled, each surface working against its neighbour. In 'White Still Life on a Small Table', the slight texture of the white underlayer, which can be seen in the shapes of the bottle and the bowl, is emphasized to form a very pale greyish tone by masking, rubbing charcoal into its surface and sanding afterwards. This becomes stronger in tone to the right to create the apple and, as a negative shape to show the table edge. The spare charcoal lines have a wonderfully granular texture that is sometimes reinforced with pencil. The pear is impasted paint, and the ochre textures are created by coarse brush bristles. Sometimes, in other works, Geoff uses additives such as sand or texture pastes to create more pronounced effects.

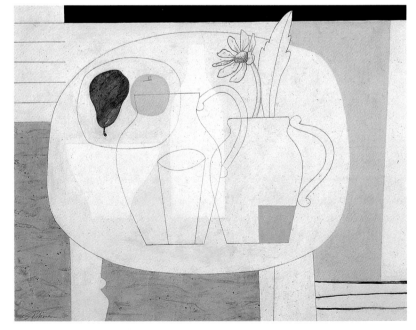

ABOVE White Still Life on a Small Table; Geoffrey Robinson
Acrylic, 483 x 635 mm (19 x 25 in)

ABSTRACT

The word abstract means either 'taken from', or 'existing in the mind rather than in fact'. Many abstracts are taken from' things seen, but are moved out of their original context, altered or concentrated to create an image that coalesces the subject matter into an emotionally or symbolic, rather than literally based, response.

For other abstract painters there is no influence on the subject other than the mood of the painter and the intuitive use of his materials. From the first mark the whole process of picture making is a journey of the imagination, with colour, tone, form and texture suggesting a mood, theme or design as they develop.

David Potter says of his work: 'My Subjects derive from symbol and myth (particularly The Odyssey). I do want people to be conscious of my medium of oil pastel – the fact that it is tactile and sometimes looks good enough to eat. My work is not planned; the images come from within, they surprise and sometimes shock me.

The creamy texture of his 'Six Fields' is broadly painted, its colour rich and dense. There is a certain character to oil pastel, particularly in the way that layer works over layer, which gives interesting textures. Using sgraffito to cut through to a lower layer is effective and low impasto is easy to achieve. Transparent effects can be created by applying a dense layer and scraping it off with a palette knife or blade, leaving a thin residue.

LEFT Six Fields; David Potter
Oil pastel, 97 x 99 mm (3³/₄ x 3³/₄ in)

Jemma Street's interest is in exploring the mark mankind makes on his environment, the way that he leaves evidence of having been at a certain place at a certain time. Her multi-layered acrylic paintings have strongly contrasting textures, one layer being broken, overlaid or peeled away to reveal others. The red is revealed, an encrusted, sand textured layer being scraped away. But even this layer is superimposed over a texture. A hand prints the mark of its palm in black, the most enduring, yet basic mark that man can make.

RIGHT Evidence 3; Jemma Street
Acrylic, 290 x 230 mm (11¹/₂ x 9 in)

ABOVE Australia 3; Kerry Paul
Acrylic and collage, 280 x 130 mm
(11 x 5 in)

The colours and terrain of Western Australia came as a shock to my daughter Kerry when she painted there. Her work reflected her joy in the unusual colours and textures that she found. She held the images in her mind, took photos, made drawings, colour sketches and notes that were later coalesced into paintings which, although not literal landscapes, evoke the texture and colour of Western Australia.

She found that everything looked makeshift, as if done as a temporary measure, but had been left like that for years, achieving a weathered patination that had a kind of quirky permanence. The '6' in the painting on the title page of this section was remembered from one of a row of battered mail boxes outside an apartment block, the apartment numbers painted crudely with white paint.

Other elements, such as the deep red-brown, refer to the sun-burnt earth and rusty corrugated iron; the grey-green to eucalyptus leaves and the threadbare dry grass of the vast plains. Greys and ochres talk of faded paint, sand and dust. She collages found elements into her work: twigs, a seed head, bits of textured cardboard, wood, metal and cloth, blend seamlessly with the acrylic paint, often stitched on with strong thread or copper wire.

In 'Australia 3', the painting is about the endless landscape. Its grey-green texture was punctuated by sudden vertical elements – a post here, rusted metal with dry vegetation against it there. The faded wooden measure is a metaphor for the vast distances of the landscape. Could the numbers indicate kilometres, miles or perhaps, days, or weeks of travel?

Kerry's method is unusual. A layer of the filter paper from used teabags is pasted onto the support – usually MDF – and scrim is glued over this. Some colouring in acrylic is carried out and a further layer of tea bag glued over. The acrylic colour – often of lilac, yellow and purple applied in both thick and thin paint – is then worked over this, scraped, sanded and glazed over as required, with other elements collaged on using glue, thread or wire.

'Australia 2' again refers to the landscape of dark burnt earth. The bits of wood and tangled wire tell of old fencing, the rusted metal and worn PVC fabric of the enduring decay.

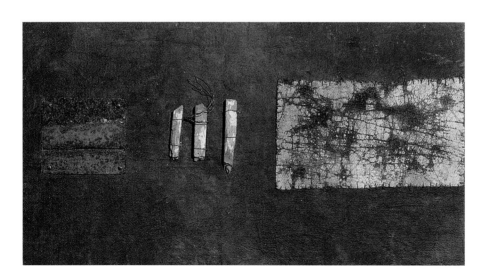

LEFT Australia 2; Kerry Paul
Acrylic and collage, 160 x 280 mm
(6¼ x 11 in)

ABOVE Ancient Pier, Simulacrum; Brian Graham
Acrylic and sand, 863 x 1117 mm (34 x 44 in)

Much of Britain is rich in Palaeolithic, Mesolithic and Neolithic sites. Painstaking archaeological excavations that pare back the millennia inch by inch are revealing the secrets of the day to day lives of these ancient cultures. Two Dorset artists, Brian Graham and Peter Joyce, have absorbed the spiritual resonance of the prehistoric landscape and have distilled it into evocative paintings that abstract from the ancient terrain. What they achieve, however, is work of strongly individual character.

For Brian, texture is never used gratuitously. It is a vehicle to describe the scoured bones, artefacts and habitats of these ancient peoples and the landscape in which they lived. Encrusted and smeared filler underpins scumbled and glazed acrylic paint, often textured with sand. Heavy impasto is sculpted with knives and spatulas or scarified with abrasives. The interplay of colour and texture is realized with great care to evoke the spirit of these ancient places. In many of his works, areas appear veiled – we are aware of shadows of things unseen or fogged by ancient mists, stains or after images of a world long gone.

Peter Joyce says of his own work: 'While I could discuss the influence of landscape in my painting, it is form that is increasingly the substance of my work. Form [composition, weight, structure, colour, spatial organization, surface, etc] is central to the success of my interpreted renderings of landscape. The paintings need to be resolved as paintings, utilizing the textures of acrylic paint, drawing and collaged elements.'

Stoney Littleton is a Neolithic long barrow near Bath. Texture has been applied with brushes, fingers and plastic scrapers, then worked into with sandpaper and craft blades, the final surface created with constant reworking. The colour evokes the time of day and season of his visit – a sunny late afternoon in October.

LEFT Stoney Littleton No. 1; Peter Joyce
Acrylic on board, 270 x 270 mm (10½ x 10½ in)

SEMI-ABSTRACT IN WATERCOLOUR

The inspiration for this painting came from a visit to San Juan, Puerto Rico. I walked up to El Morro, the fortress that guards the harbour entrance, on the way passing the cemetery with its sugar pink domed church. The walls of the fortifications are massive, up to twenty feet thick in places and so tall that the view is only visible through the step down of the crenellations. Flags were everywhere, demonstrating the Puerto Ricans' pride in this world heritage site. I put all these elements together in a painting that is based on separate and stylized images brought together into a single work.

Stage 1

I began by sketching out a design and transferred this to watercolour paper. I wanted to recreate the textures I had seen and saw this as a multi-layer watercolour and decided to use a wax candle and the grain of the watercolour paper to provide a resist texture.

I laid in pale washes of green, blue, pink, beige and yellow, then painted an impression of the stone of the fortress wall. Its sloping top I left as white paper. The windows of the church were roughed in with a mid-grey and when this was dry a piece of candle was laid flatly on the paper and, without too much pressure, rubbed across the paper's surface, providing a resist for subsequent layers. I had to be careful not to overdo this – once on there is little chance of removing wax. Holding the paper at an angle to the light, I could see the shine on the areas to which the wax had adhered.

Stage 2

I overlaid darker washes to the sky (manganese blue), the sea (ultramarine), the roof (orange), the wall (grey), and the grass (green). I then ghosted in the flag over the wall texture. Finally, with residue of the grey, I added the shadows under the domes of the church. I think that the clean light and the Caribbean sun are becoming evident.

Stage 3

I wanted to add more texture to certain elements in the painting and decided to use random cross hatching on the domes and walls of the church, softening the white of the roof edges and oval window surround with blue and darkening the window openings with mixed black applied in hatched strokes.

I felt that the grey overlay of the stone wall had caused some of the individual stone shapes to become lost, so I added some defining texture. Not only did this bring out the stone, but also made the flag element appear more transparent. The final touches were in the area of the graveyard. I added vertical lines in the green and defined the white crosses by painting the large stone grey. The last touch was to add an echo of the stone walling in the sea wall beyond.

BELOW Old San Juan; Tony Paul
Watercolour, 241 x 216 mm (9¹/₂ x 8¹/₂ in)

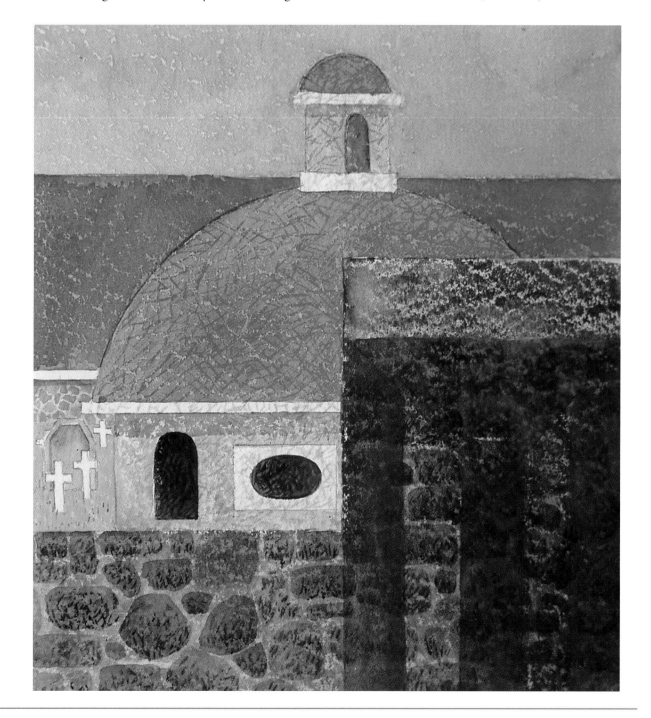

ABSTRACT IN MIXED MEDIA

The inspiration for my abstract was a shanty area near Basseterre in the Caribbean island of St Kitts. Corrugated iron is the main material used in these tumbledown dwellings, often patched, overlaid and sometimes painted with colours that have faded in the hot sun, creating wonderful shapes and textures.

Stage 1

Having first worked out a design based on overlapping forms, I drew the basic elements on to a panel with pastel. Over this I knifed acrylic modelling paste. I found the palette knife marks too smooth so sponged over the surface to give a pitted texture and reinforced the shapes' outlines by drawing into the wet paste with the point of the knife. When this was dry, I flattened the surface a little with sandpaper. With dilute blackish, brownish and orangey washes of acrylic paint, I washed over the panel and then gently wiped the surface, leaving the colour in the tooth of the texture.

With a brownish mix I worked in shading to indicate corrugations. I added some marks with pale green oil pastel, which sat on the top of the texture without affecting the acrylic. As a bonus, the greasy pastel acted as a resist to further applications of acrylic. I added more marks with red, blue and burnt sienna.

Stage 2

I wasn't happy with the top line of the tan coloured shape so I made it more concave with modelling paste and built up its leading edge and that of the top edge of the right hand rectangular shape. When it was dry, I sanded it down a little. I carried on working with the oil pastels, blending and overlaying the colours. I then introduced a violet, red violet grey, yellow ochre and pink, the warmer colours emphasizing the lighter part of the corrugations and the cooler colours the darker areas.

Stage 3

I felt that the oil pastel looked a little 'raw' so washed over the whole painting with diluted black acrylic ink. The oil pastel repelled the ink, which settled into the grain, giving the colour better definition. The colour was still too bright so I worked all over the painting with white pastel, blending it a little with a finger, then repainted the rusty oblong with a an orange-red mix of acrylic. In this painting, the edges are important so I reinforced them with white and red oil pastel. I feel I have captured something of the textures of the decayed yet somehow eternal buildings, the colours of grime, of faded paint and rust.

BELOW Basseterre, St Kitts; Tony Paul
Mixed media, 305 x 305 mm (12 x 12 in)

GLOSSARY

Acrylic: a quick drying water-mixable painting medium based on acrylic resin – see pages 10–11.

Acrylic mediums: additives that can be mixed with acrylic paint to change its character: to increase gloss, make it matt surfaced or slow its drying.

Aerial perspective: the effect where colours and tones soften and tend towards blue-grey as they recede into the background.

Alizarin crimson: a popular and powerful deep purplish red introduced into the artist's palette in 1868. Nowadays it is considered to be less than adequately lightfast. Artists are advised to use the more permanent 'hue' versions.

Burnt sienna: a lightfast, reddish-brown earth pigment made by roasting the raw sienna pigment. It is a rich transparent brown that is used in all painting media.

Burnt umber: a lightfast deep brown earth pigment made by roasting the raw umber pigment. It is transparent and used in all painting media.

Cadmium red: opaque, lightfast reds made in a range of hues from orangey to purplish. They work well in oil, acrylic, gouache and tempera but are not as useful in watercolour because of their opacity (watercolour is really a transparent medium) although they are often put into boxed sets. They are not used in pastels because of toxicity regulations.

Cadmium yellows: opaque and lightfast, they are made in a range from pale lemon through to rich orange. Best used in oil, acrylic, gouache and tempera, they are less useful (although used by some) in watercolour because of their opacity and, sometimes, unpredictable effects in washes.

Cobalt green deep: a deep green made from oxides of cobalt and zinc. The pigment is expensive and weak. It is best used for underpainting in oils, where its low oil and fast drying characteristics are of value. Not a popular colour, usually found only in oil and watercolour ranges.

Coeruleum (cerulean): a greenish opaque mid-blue introduced into the artist's palette by George Rowney in 1870. Made from cobalt and tin oxides. Nowadays it is a very expensive, but nevertheless essential, colour in most palettes, perhaps except watercolour, where it is best replaced with manganese blue, a similar colour, but transparent.

Complementary colours: the colours that directly oppose each other in the colour wheel: red/green, yellow/violet and blue/orange.

Contre jour: a French term meaning 'against the light'. Paintings made looking into the light.

Egg tempera: an ancient translucent medium made from pigments blended with egg yolk and diluted with water. The colours are applied thinly often in hatched or dabbed strokes. It is characterized by its ability to give clear, glowing colours which dry to give a semi-matt finish. Most egg tempera painters make their own paints, but Daler–Rowney supply an excellent range of egg tempera colours in tubes.

Flake white: an opaque, flexible white, nowadays used only in oil painting. It is made from lead and so is poisonous. In my view still the best white for oil painting.

Gamboge hue: a watercolour pigment colour made to look like the unreliable natural gum/pigment gamboge. (See also 'Hue'.)

Glaze: laying a transparent colour over an underlayer. Often used in oil painting to create depth of colour, with a painting medium added to increase transparency while maintaining a good viscosity.

Gesso: a type of priming. True gesso is made from rabbit skin glue, slaked gypsum or whiting and titanium or zinc white pigment. It is the perfect sub-structure for egg tempera painting. As with egg tempera, painters usually make their own panels – a tedious but ultimately satisfying business. A 'gesso primer' is made by most manufacturers and is excellent for treating surfaces ready for oil and acrylic painting. It doesn't have the absorbency of true gesso and therefore is unsuitable for egg tempera paintings.

Gouache or bodycolour: a highly pigmented watercolour to which an opaque filler has been added, to give it opacity. The light colours tend to dry darker than when applied and the dark colours dry lighter. With gouache, light colours such as yellows can be painted over darks without any loss of brilliance. The colours dry to give a matt surface.

Hardboard: a thin building board often used to panel in doors. One side is smooth, the other has a mechanical mesh texture. Offcuts make cheap and ideal painting boards which can be primed with acrylic gesso primer for oil and acrylic or true gesso for egg tempera paintings. Always use the smooth rather than the mesh side, which some misguided individuals think looks like canvas – it doesn't. The surface is too coarse and will make the painting look cheap and amateurish.

Harmonic colours: colours that lie next to one another in the colour wheel.

Hue: there are two meanings to this word. It can be used as another word for colour – 'the roof was a reddish hue'. Or it can be used to describe a colour that has been made from cheaper pigments to imitate a (usually) more expensive colour – 'cadmium red (hue)' for instance.

Impasto: the thick application or building up of a paint surface to give a three-dimensional effect. Most often used by painters in oil and acrylic.

Indian red: an opaque red earth pigment used in all media. It has a purplish bias, making good greys.

Indian yellow: formerly made from the urine of Indian cows it is nowadays (fortunately) a hue colour, made from synthetic pigments. It is transparent with a leaning towards orange.

Lemon yellow: a pale greenish yellow that can be made from a number of pigments, some transparent, others opaque. It makes bright greens but dull oranges.

Local colour: the actual colour of an object under good, direct light and unaffected by shadows.

Manganese blue hue: a transparent, bright greenish blue similar in colour to coeruleum. It makes bright green and soft, muted purples. Nowadays, the colour is only available as a hue colour as the original pigment is no longer manufactured.

Masking fluid: a latex solution that is applied to paper with an old brush, cocktail stick or pen to preserve the white paper. When dry, it resists a watercolour wash and later can be easily rubbed off to enable further layers of paint to be applied if desired.

MDF: medium density fibreboard. A similar board to hardboard, but smooth on both sides and available in a variety of thicknesses: 6mm is ideal. MDF is more expensive than hardboard but offcuts can still be obtained at bargain prices from your local wood yard. Beware of cutting or sanding the boards yourself as the dust from some types of MDF can be carcinogenic.

Medium (plural media): a particular type of paint: oil paint, acrylic, watercolour etc. Can also mean a liquid that can be added to a paint to improve certain characteristics, such as impasto or gloss.

Monochrome: one colour, usually a work in shades of grey or brown, but can be of any colour. Always tonal.

Oil: oil paint made from pigments ground in a drying oil, usually linseed, but sometimes poppy, safflower or sunflower oils are used in certain colours and the whites because they yellow less than linseed. It is diluted with solvents such as turpentine.

Oil pastel: sticks of pigment bound in fats and waxes that can be used in a similar way to a chalk pastel. This type is often preferred by those who suffer from respiratory complaints as no dust is created.

Pastel: sticks of pigment mixed with a gum binder. Each base colour is also made in a range of tints – paler versions, and shades – darker versions. Pastels adhere to the painting surface by being gripped in the tooth of the paper.

Permanent rose: a modern pigment made from quinacridone that is more lightfast than the old rose madders made from the madder root. It is a bright, yet delicate pink red with great transparency – a must for flower painters.

GLOSSARY

Phthalo blue and green: a deep, greenish blue and a bluish green, made from copper phthalocyanine. They are powerful, transparent and lightfast.

Primary colours: colours that cannot be mixed from other colours, such as reds, blues and yellows. It can also mean colours that are mono-pigments, such as viridian, which is created green, not a binary mix of blue and yellow.

PVA: polyvinylacetate. A water-based glue that dries almost transparent. When dry it is inert and will not become acidic as it ages, as do many adhesives.

Quinacridone burnt orange: a red-brown made from one of the marvellous quinacridone pigments. It is lightfast, transparent and can be found under various pseudonyms in acrylic and watercolour ranges.

Raw sienna: a natural brownish semi-transparent yellow earth colour that was literally dug from the earth and ground to a fine powder which was then used as a pigment. The best grades came from Tuscany or the Harz mountains in Germany. Nowadays synthetic versions are preferred, based on Mars yellow.

Raw umber: a semi-transparent natural brown earth colour from Italy and the Eastern Mediterranean. Called 'raw' to distinguish it from burnt umber, a roasted version of the pigment.

Saturation: the strength of a particular colour, sometimes called the chroma. The stronger the colour, the higher the degree of saturation.

Scumble: a veil of colour, usually paler, that is scrubbed over another colour to partially obliterate or modify it.

Secondary colour: the result of colours that are mixed from two primary colours, such as orange, green and purple.

Sgraffito: marks made by scratching through a painted surface.

Temperature counterpoint: the laying of a cool colour against one that is warmer, or vice versa.

Tertiary colours: mixed from a *secondary colour* and the remaining primary colour. These are usually dull, grey or brownish colours.

Titanium white: the densest white, good for obliterating and highlighting but can produce chalky colours in mixes.

Tonal counterpoint: the placing of one tone against another to make each stand away from the other.

Tooth: the texture of a surface. A paper with a good 'tooth' will pull pigment from the pencil or pastel to make a strong mark. Surfaces with little tooth will give only weak colours/tones when used with dry media.

Ultramarine: discovered in France in 1828 and properly known as French ultramarine. It is a transparent, lightfast, bright deep purplish blue and a mainstay of the artists' palette.

Viridian: an unnatural, transparent blue green. Not used much from the tube but a wonderful mixer, giving a large range of useful greens. It has good lightfastness and can be used in all media except for acrylic, with which it is incompatible.

Wet-on-wet: painting into wet paint with more wet paint. Its most popular use is in watercolour but it can be used to effect in all 'wet' media.

CONTRIBUTORS

I would like to thank the following artists for their valuable contributions to this book.

Caroline Bletsis – p 105 (top & bottom)
9 Larmer Close
Fleet
Hants GU51 5AY
England

Richard Caplin – p 84 (bottom)
344 Goodwood Avenue
Hornchurch
Essex
England

Alan Cotton – p 36 (bottom)
Brockhill Studio
Colaton Raleigh
Devon EX10 0LH
England

Gregory Davies – pp 14, 52
Crabieres
Le Bugat
Bourg de Visa
82190
France

Daphne Ellman
– pp 102 (top & bottom), 104 (top)
26 Launcelyn Close,
North Baddesley
Southampton
Hampshire SO52 9NP
England

Lisa Graa Jensen RI – p 106 (top)
45 Wodeland Avenue
Guildford
Surrey GU2 4JZ
England

Brian Graham – p 117 (top)
C/o Hart Gallery
113 Upper Street
Islington
London N1 1QN
England

Pauline Gyles RMS FSBA HS.
– p 17 (bottom)
3 Old Coastguard Road
Sandbanks
Poole
Dorset BH13 7RL
England

Lauren Hayes-Bissell – p 107 (bottom)
987a Wimborne Road
Moordown
Bournemouth
Dorset BH9 2BS
England

Dennis Hill – p 17 (top)
91 Upton Way
Broadstone
Dorset BH18 9LX
England

Ronald Jesty – pp 54 (top), 55 (top),
56 (top),58 (top),
59 (top, middle & bottom), 60, 84 (top)
Flat 11
Pegasus Court
South Street
Yeovil BA20 1ND
England

Peter Joyce – p 117 (bottom)
6 Pound Close
Poole
Dorset BH15 3RX
England
www.peterjoyce.org.uk

David Kelly – p 108 (top & bottom)
c/o RC Arts
17 Wessex Trade Centre
Ringwood Road
Poole BH12 3PF
England

Peter Kelly RBA – pp 18 (bottom),
31 (bottom)
The Chestnuts
The Square
Stock
Essex CM4 9LH
England

John Patchett – p 89
www.john-patchett.co.uk

Kerry Paul
– pp 113, 116 (top & bottom)
3 Fernvale Terrace
Beech Hill
Headley Down
Bordon
Hants GU35 8EG
England

Tony Paul – all illustrations, other than those listed
Church Lane Cottage
Cheselbourne
Dorchester
Dorset DT2 7NJ
England

David Potter – p 115 (top)
46 St Michaels Lane
Bridport
Dorset DT6 3RB
England

Geoffrey Robinson – p 114 (bottom)
4 Shingle Bank Drive
Milford-on-Sea
Lymington
Hants SO41 0WQ
England
www.geoffreyrobinson.com

Sonia Robinson RSMA SWA
– p 82 (top)
3 Paul Lane
Mousehole
Nr Penzance
Cornwall TR19 6TR
England

Frances Shearing – pp 30 (bottom),
32 (bottom), 33 (bottom), 34 (bottom),
57 (top)
30 Victoria Park Road
Bournemouth
Dorset
England

Hilda van Stockum – p 57 (bottom)
c/o 28 Castle Hill
Berkhamsted
Herts HP4 1HE
England

Jemma Street – p 115 (bottom)
15 Firs Glen Road
Bournemouth
Dorset
England

Nick Tidnam RBA – p 114 (top)
16 Roebuck Road
Rochester
Kent ME1 1UD
England

ACKNOWLEDGEMENTS

I would like to thank the following for their help in the production of this book: Rosemary Wilkinson, Corinne Masciocchi and Clare Hubbard of New Holland who gave a guiding hand and encouragement, and to Ian Sandom for his design work.

My grateful thanks also go to the very talented artists: Caroline Bletsis, Richard Caplin, Alan Cotton, Gregory Davies, Daphne Ellman, Lisa Graa Jensen, Brian Graham, Pauline Gyles, Lauren Hayes-Bissell, Dennis Hill, Ronald Jesty, Peter Joyce, David Kelly, Peter Kelly, John Patchett, Kerry Paul, David Potter, Geoffrey Robinson, Sonia Robinson, Frances Shearing, Hilda van Stockum, Jemma Street, Nick Tidnam, and to the models who sat so patiently for me. Special thanks to my good friend Seán Street for his foreword and lastly a big thank you to my wife, who stoically put up with the outside paintwork not being repainted because I was working on the book.

INDEX

Page numbers in *italics* refer to captions

abstract paintings 115–117, 120–121
acrylics: in abstract painting 115, 116, 117
 additives for 15, 16
 and collage 116
 in marine paintings 79, 80, 83
 as oils 18
 and sand 117
 in semi-abstract paintings 114
 supports for 10, 11
 as watercolour 17
After the Holiday-makers Have Gone (Paul) *80*
Al Fresco (Patchett) *89*
All Set for Quebec (Paul) *78*
Ancient Pier, Simulacrum (Graham) *117*
animals 102, 103, 105–108, 111–112
Apple on a Fence (Paul) *96*
Artist's Father (Paul) *67*
Artist's Garden (Paul) *19*
At the Waterhole (Kelly) *108*
Australia 2 (K. Paul) *116*
Australia 3 (K. Paul) *116*
Autumn over the Roofs (Paul) *90*

Bait Diggers, Poole Harbour (Paul) *80*

Barges on the Seine (Paul) *82*
The Barn Out Back of Noisy Dave's (Paul) *29*
Basseterre, St Kitts (Paul) *112*
Bathing Robin (Paul) *47*
Below the Alhambra, Granada (Paul) *90*
Bertie Takes the Lead (Paul) *41*
Biding His Time (Paul) *112*
Big Ben, Evening Light (Paul) *100*
Bill's Shed (Paul) *93*
The Bird Table (Paul) *47*
birds, to depict 102, 104, 109–110
Blue, Ochre and Red (Tidman) *114*
Blue Whale (Bletsis) *105*
boards: canvas 10
 Daler 10
 gouache 12
 textured 13
boats 82, 85–86, 87
Brian (Paul) *66*
brushes 21–23

Cabbage Field, Dunster (Paul) *18*
canvas/canvas board 10
card effects 30
Cats at Carnac (Paul) *24*
ceramics, to depict 55
Chattel House, St Kitts (Paul) *95*
Cheetah (Paul) *107*
Clay, Copper, Brass and Glass (Paul) *56*

clingfilm see plastic wrap
cloth, to depict 58
clothing 71–72
cloud effects 35, 40–41, 48
The Cobbler (Paul) *71*
collage 116
Collared Doves (Paul) *104*
Connemara, Early Morning Light (Cotton) *36*
A Corner of the Farmyard, Narramore Farm (Paul) *43*
A Corner of Santa Maria della Salute, Venice (Paul) *94*
The Cow Dealers (Jensen) *106*
Cows, Evening Light (Davies) *14*

Daler boards 10
Derelict Building, Bridgetown, Barbados (Paul) *96*
Dinghies (Paul) *79*
Dissolve Two Tablets in Warm Water (Jesty) *56*
Dominican Monastery (Kelly) *18*
Dominique (Paul) *71*
A Dorset Footpath (Paul) *44*
Dorset Landscape (Paul) *49*
dry brush effects 36, 83, 106
 brushes for 22, 23
 paper for 11
Dunlin and Lobster Pot (Paul) *83*

INDEX

egg tempera: in marine paintings 81, 82
 in depicting buildings 92, 94, 96
 portrait in 65
 still life in 61–62
 supports for 12
 techniques 19
Evening Light (Ellman) *104*
Evidence 3 (Street) *115*

Farm Buildings, Bagneux, France (Paul) *98*
feathers, to depict 102, 104
fields, to depict 42–43
flowers, to depict 57
foliage effects 22, 23, 26, 44, 49, 97
Following the Ferry Out (Paul) *78*
frottage 37
fruit, to depict 57, 59, 96
fur, to depict 102, 103, 105, 107

Garden Spider (Paul) *25*
A Gateway, Sissinghurst Gardens (Paul) *91*
gesso panels 12
Gin and Tonic (Jesty) *54*
glass, to depict 54, 92
gouache: in depicting buildings 96
 supports for 12
 techniques 19
granular effects 28
grass effects 23, 42–43, 44, 49, 83, 107, 109, 110
Grey Day, Portsmouth (Paul) *79*

highlights 29, 60, 81, 95
 on buildings 97
 on fur 102, 103
 in portraits 67, 74
 on water 79
Honesty (Paul) *55*

impasto 14, 115, 117
 medium 15

Jeanette at the Sink (Paul) *9*
Joanne (Paul) *76*

Kerry (Paul) *72*
Khan (Paul) *103*
Kingfisher (Paul) *45*
knives: painting 14, 36
 palette 14
Kularb (Paul) *72*

lace effect 61–62
Lady in a Hat (Gyles) *17*
Landscape (Shearing) *33*
The Last Paddle of the Day (Paul) *88*
Lichtenstein Gorge, Austria (Chaplin) *84*
lifting off 35
light: angle of 58
 direction of 59, 73
 see also reflected light
Lilies and Pomegranates (Shearing) *57*
Lobster Shack, Cape Neddick, Maine (Paul) *83*
Low Tide, Lyme Regis (Paul) *86*
Low Tide, West Bay (Paul) *35*
Lynsey (Paul) *65*

Maiden Castle (Paul) *41*
masking 25, 97
metals, to depict 56
mixed media 84
 abstract in 120–121
modelling paste 15
Monet, Claude 14, 64
mountboards 12
Music and Champagne (Paul) *6*

Nagababu (Paul) *69*
Narramore Farm (Paul) *8*
Niki (Paul) *65*
No. 6 (K. Paul) *113*

oil(s): additives for 15, 16
 buildings in 99–100
 impasto 14
 landscape in 50–51
 in marine paintings 78, 80, 81, 82
 portrait in 75–76
 in portraits 66
 in semi-abstract paintings 114
 and sponging 26
 supports for 10
 techniques 18
 water-mixable 75
Old San Juan (Paul) *119*
On the Sea's Fringe (Shearing) *34*
On the Window Sill (Paul) *94*

paper: for egg tempera 12
 pastel 12, 13
 watercolour 11, 12
 weights 11
pastels: animal painting in 111–112
 landscape in 48–49
 marine painting in 87–88
 oil 115
 in depicting buildings 90
 supports for 13
 techniques 20
paths, to depict 44
The Patriarch (Kelly) *108*
pen and wash 94
Persimmon and Plums (Jesty) *60*
Pigment Jar and Mug (Paul) *54*
plastic wrap effects 34, 105
Pomegranate (Shearing) *32*
Portland Bill Looking Eastward (Jesty) *84*
Portrait Study (Paul) *26*
Portrait (study) (Paul) *68*
potato cut 27
Preparing Gondolas, Venice (Paul) *91*
primer 10, 12
printing 27
PVA and plaster effects 33

Red Admiral (Paul) *37*
The Red Bucket (Paul) *81*
Reflected Clouds, Tarn, France (Davies) *52*

INDEX